Foreword

This exhibition of Alfred Jensen's recent work was chosen as the official United States representation at the XIV São Paulo Bienal, held from October 1 through November 30, 1977. Thus the achievements of Alfred Jensen were put into important international focus for the first time by this exhibition organized for the Gallery by Curator Linda L. Cathcart.

Alfred Jensen, a unique painter and, even in the art world, a maverick, has pursued an independent course and personal mythology which continue to serve him as a source of inspiration. The review of two decades of his work will indicate the shift away from figuration viewed through the checkerboard-like structures towards the magical fields reminiscent of cabalas, mandalas, and other ritualistic forms. Brilliant saturated color, frequently an allegory of solar energy, permeates the space beyond the work and envelopes the viewer as well into its truly spectacular aura.

I thank Ms. Cathcart for her diligence, acumen, and skill in performing double duty, resulting from the International Exhibition Committee's choice of this show for the 1977 São Paulo Bienal in addition to normal organizational planning. The show's organization was thus two-fold, curating and writing essays in advance of its installation in Brazil with concomitant requirements such as a foreign language catalogue, etc. and thereafter preparation of the show for its opening in Buffalo. I extend my thanks also to Marcia Tucker who wrote on the artist's work for the exhibition catalogue.

Finally to the artist himself and his wife, Regina, without whose extensive and always amicable cooperation the exhibition would have been unachievable, I also extend my sincere thanks and homage.

Robert T. Buck, Jr., *Director*
Albright-Knox Art Gallery

Acknowledgments

An exhibition of this scope can only be achieved with the cooperation of an excellent staff and many friends and advisors. From the Albright-Knox Art Gallery, I owe a debt of gratitude to Robert T. Buck, Jr., Director, for continuing to provide the guidance and support so necessary for my work as a curator; my secretary, Norma Bardo, for her unfailingly cheerful assistance at all times and Angela Tomei for organizational and secretarial skills; Jane Nitterauer, Registrar, and Alba Priore, Assistant Registrar, for organizing the details of packing and shipping; John Kushner, our head preparator, for invaluable advice; Annette Masling and the Library staff for assembling the catalogue bibliography; Charlotta Kotik and Brit Klaas for their help with translations; Serena Rattazzi, Coordinator of Public Relations, for public information work, editorial advice and hours of tedious proofreading; Jackie Holland and Leta Stathacos for moral support; Christopher Crosman, Assistant Curator of Education, and Nancy Miller, Lecturer, for the use of their unedited videotapes of Jensen; Linda Havas for assisting with photo documentation; H. M. Jones and Karen Spaulding for editorial assistance and Paul McKenna, the designer of the catalogue. Lauren Berger, Ellen Carey and Ken Davis assisted me in various capacities as did the staffs of many galleries and museums who provided photographs and documentation from their files. Laura Fleischmann, my intern, worked for many months compiling the astute chronology and helping me with all other aspects of organization. I would also like to thank Dennis Ashbaugh for much understanding and critical dialogue; Leila Hadley Musham for the use of her unpublished manuscript of Jensen's life; Irving Sandler for informative discussion and the use of his and Michael Torlen's taped interview. Mr. and Mrs. Henry Luce III graciously gave me the opportunity to see Jensen's works in their collection. Without Marcia Tucker's skills this exhibition would not have been possible; it was she who long ago included Jensen's work in *The Structure of Color* exhibition, which was for me the turning point in my love for and understanding of his work and the beginning of our dialogue about this great man which has resulted in our working together on this catalogue and exhibition.

Ultimately, I can never thank enough Alfred, Regina, Anna and Peter Jensen for taking me into their lives and extending their assistance and encouragement as well as their hospitality to me. I will always remember these times with pleasure.

Linda L. Cathcart, *Curator*
Albright-Knox Art Gallery

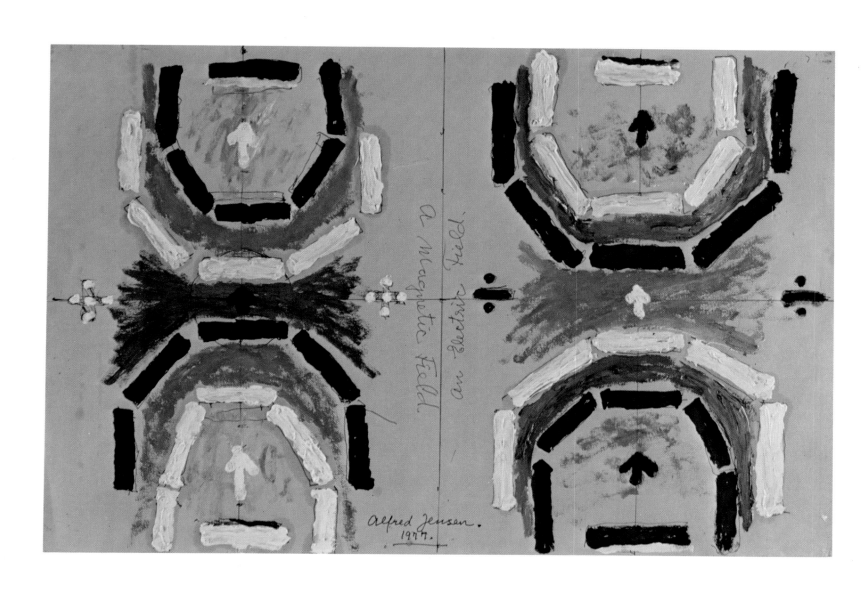

Diagram for a Prism Machine. 1977

April 1977

One afternoon during the year 1921, I was walking down a street in San Diego, California. I suddenly saw the edge of a young man's face, a nose. I called out to the owner of the profile, "Karl, remember that I drew your portrait in 1915, when we were children in school?" "Of course, I remember, Alfred," he answered, "and I still keep the portrait as a remembrance of our school days. That was 6000 miles away and six years ago, in Horsholm, Denmark."

The edge of things, a profile, coupled with a past event, has always made me leap like an inspired diver off a board.

Edge events have occupied me for years — the edge of color as it is observed in a prism. Goethe wrote in *Beitrage zür Optik*, 1791, paragraph 33:

> *The prism as an instrument, was looked upon with submissive awe and humility in the Eastern lands; so that the Chinese emperor gave himself the right to be the unique owner, as he insisted, by divine right of Majesty, to behold these beautiful appearances for himself alone. We in all ages from youth to old age look with wonder on the prismatic instrument because upon its use depends most of the color theories: therefore, to begin the study of color we must concentrate on this object.*

While the study of Goethe's color theory has engaged me over a twenty-year period, it is in the past three years that I returned to it, as well as new readings in contemporary physics and electro-magnetism and constructed the prism machine.

The Prism Machine

As a space pilot approaches earth from outer darkness, a blue luminous atmosphere meets his eyes. The cool color hues are stalled in the proton-filled outer shell, not able to penetrate inward to the surface of the earth. Instead the protons create an electro-magnetic field. Areas around the turning globe oscillate until the protons are absorbed by the negative south polarity.

When the earth's night shadow dominates its own atmosphere, the electrons in the electric field produce the hot color hues. The atmosphere turns from blue to orange.

The dark of the universe and the light of the sun are both sources of energy.

In exploring the prism a similar phenomenon takes place.

A total prism is a circular unit of 360°. This unit is split in two half circles, each 180°. One part is the black prism, the other part is the white prism.

On a large piece of window glass, I glued twenty-two prisms on both sides, creating a prism sandwich. This made an opposition of eleven black and eleven white prisms.

I placed the prism machine facing a north skylight through which came the reflected light of the sun and the dark dome of the universe.

I looked at the prism machine through another prism, held in front of my eyes. The color hues appeared: black traveling towards the white showed the blue or cool color hues, the protons \cdots . White traveling towards black showed orange or the hot color hues, the electrons \div . The dark spectrum hues are six and the light spectrum hues are six, to be seen in the paintings and diagrams of 1975-1977.

The ancient Chinese labeled Heavenly 1-3-5-7-9, the odd numbers, and designated Earthly 2-4-6-8-10, the even numbers. In my two diagrams of 1977, I express the dark prism's six spectral color hues as the placement for areas 0-1-3-5-7-9, brought to a completion of twenty, with the aid of a reversed area placement of 0-19-17-15-13-11. The result is a balanced computation of 5 x 20 = 100.

I harmonize the white prism's six spectral color hues by the use of 10 twice. I build by 0-2-4-6-8-10, and place in the reverse area the number sequence 0-18-16-14-12-10. I arrive at an even number composition of 5 x 20 = 100.

Thus, I demonstrate a unifying method characteristic of the vigesimal system first created by the ancient people of China and the Maya.

Modern number abstractions have not meant much to me, nor have mystical associations of number. Ancient calendar systems, the edge of the sun reappearing, have been a source of my concrete and symbolic number structures. I follow Pythagoras, who said, "Let the true principle be known, the beginning is the half of the whole."

My use of numbers is governed by the duality and opposition of odd and even number structures.

Besides, I am still attentive to the revelations of the four corner edges of a square and the rectangular picture plane.

The edges of invisible shapes at the threshold of my awareness — the monuments and objects left by the ancient people, for example, are all in my mind together with an education in modern art in Germany, France, and the United States. What to make of it, but an allegory, in a new pictorial structure.

In a school story about his family, six-year old Peter wrote, "My father is strong and good because he paints solar energy."

Alfred Jensen

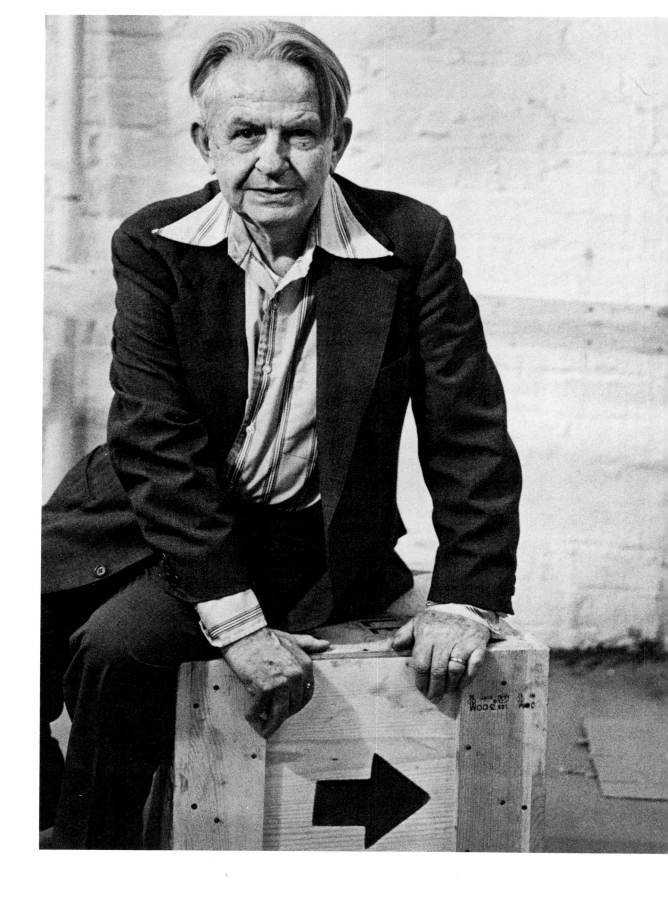

Alfred Jensen, 1977

Alfred Jensen: Paintings and Diagrams From the Years 1957-1977

by Linda L. Cathcart

At the age of 74 Alfred Jensen takes his place as one of the major artists of our time. Because little has been written about this man's remarkable career and even less about his work his recognition is belated. Jensen's isolation — he does not surround himself with followers or acknowledge disciples — has contributed to the delay in his taking his proper place in the history of American painting. Lately Jensen has had infrequent contact with other artists; he does not teach and does not exhibit regularly in any gallery in America. He has never sought the avenues which measure success by sales, publicity or prizes. He has, therefore, been thought to be inaccessible and difficult. Actually his work *is* difficult, multifaceted, overlaid, telescopic and encyclopedic; it reflects its creator. The artist himself is persistently prolific, highly intellectual, incredibly witty and unconventional. He can no more be taken in at one glimpse than can one of his paintings.

Because of his isolation and sporadic exhibition record, very little of Jensen's work has been seen in America (more has been seen in Europe where he has exhibited regularly since 1963). Interestingly, it is other artists who are most familiar with Jensen's work. Critics, with a few notable exceptions, have stayed away or have written generally of his primitive or mythical vision; his work is not easily reviewed in a few sentences. With the exception of nine paintings exhibited at the Guggenheim Museum in 1961, Jensen has never had a one-artist museum exhibition in this country before this time. However, neither Jensen nor his work reflects neglect. Because Jensen's vision is so unique, it feeds on sources not integral to the art world or its establishments. Jensen studies religion, philosophy, science, mathematics, physics, and astronomy. It is from these studies that his work is inspired. Aside from scant exposure, Jensen's work has been obscured by critical attempts at categorization. He has, at various times, been referred to as a constructivist, abstract expressionist, hard edge painter, pop artist, abstract imagist, minimalist, and conceptual artist. While certain aspects of some of Jensen's paintings may indeed reflect these movements, he himself has never been concerned with their primary issues. Wieland Schmied wrote in his preface to the catalogue accompanying Jensen's retrospective exhibition at the Kestner-Gesellschaft, Hanover, in 1973:

However many aspects of the avant-garde of the sixties and the beginning of the seventies may be traceable or contained in his work. His own theories have kept him apart, his central role remains to be discovered. Beyond the distance of respect due to him, the younger generation perceives him as a self-willed but related spirit, not only as a companion of the road but also as a contemporary. [1]

As his mature career spans two generations it is difficult to discuss Alfred Jensen in terms of his artistic contemporaries. His age places him with Willem de Kooning, Jackson Pollock, Mark Rothko and Clyfford Still. His style, however, developed later than theirs and emerged in the early 1950s along with that of artists such as Helen Frankenthaler, Allan Kaprow, Claes Oldenburg, Robert Rauschenberg and George Segal, among others. He has continued to make innovative work through the 1960s and into the 1970s and, therefore, has also worked in parallel with Mel Bochner, Ellsworth Kelly, Kenneth Noland and Frank Stella. While he is not closely or easily aligned with other artists in terms of style or method his philosophy might perhaps be compared to that of Joseph Cornell, Jean Dubuffet or Barnett Newman who share with him an interest in the universal, or his friend Sam Francis whose interests in oriental philosophy coincide with Jensen's. Alfred Jensen's independence has, in a way, been fortunate in that it has left him free to study and explore. Jensen is committed to exploring the "universal" and the "truth." He has said:

There are many facets of truth – it is like a many-faceted diamond. There is no such thing as a truth. You must know all the facets before you can present the diamond . . . I believe in preparation. The idea of a solution – step by step. Sometimes it takes 20 years but in the meantime you make a lot of paintings. [2]

Jensen works on his paintings one by one. They are neither serial nor are they formally predetermined.

My concept is primarily concerned with my practice of the art of the sign. In determining the particular definition of a visual sign I try to present it in its most simple term. Structuring and combining both color and form, in its composite characterization I arrive at the sign. I carry it from this beginning unto its manifold rendering . . . I insist that the art of painting is made up of the visual body dealt with in the employment of the sign. The sign, therefore, must be rendered in its true objective image so that it can function in its direct and pure creative act. [3]

Included in this survey of twenty years of Jensen's career are paintings from 1957 to the present. The viewer is best served by seeing them in the terms in which Jensen painted them — as individual transcriptions of events and occurrences, both personal and general, which correspond, relate or interact.

Alfred Jensen's remarkable life story forms a background for understanding his present artistic position. Born in Guatemala to a Danish father — employed as a builder — who, Jensen says, "believed in structures," a Polish-German mother whose father Jensen believes was an artist, and tended by an Indian nurse of Mayan descent, Jensen finds he can trace the sources for his work to the very beginnings of his life.

In 1924, at the age of twenty-one, Jensen became a serious art student in San Diego at the School of Fine Arts, where he recalls being told he had no talent in commercial art. In 1926 he left for Germany to attend Hans Hofmann's school in Munich. His early drawings were in an academic manner. Jensen understood the space and push/pull theories of Hofmann and his students, but preferred to draw after the old masters whose work he saw in Munich's Neue Pinakothek museum. He recalled:

I disliked the German idea of making art into a solution of problems rather than an expression of life experiences . . . I drew from Dürer and Bruegel despite Hofmann's plane, push and pull and spatial concepts . . . He [Hofmann] thought that nature should be ordered according to man's concepts rather than the imitative response. I saw the relationship between the old masters and nature which his modern doctrines didn't account for.[4]

In the summer of 1927, at Hofmann's summer school in Capri, Jensen met Mrs. Saidie A. May, an American collector and patron of the arts, herself an artist. She offered her patronage to Jensen and with her help he was able to continue his education in Paris after he broke with Hofmann. At the Académie Scandinave in Paris Jensen studied sculpture under Charles Despiau and painting with Othon Friesz and Charles Dufresne.

Dufresne thought that my painting was too willful. He said that in Germany they treated life from a problematic viewpoint, but that in France the student was taught to be responsive to life, to open up to his surroundings. Despiau showed us the vision of nature. Dufresne taught us tradition. He knew Renoir and Pissarro personally, [but] before you could turn modern he said you had to know tradition.[5]

It was Dufresne who encouraged Jensen to paint in thick impasto. He believed that over a long period of time oil paint, if applied normally, would sink into the canvas and the surface of the pictures would become glassy. Jensen painted his way through Fauvism and Impressionism. It is possible that studying the Fauves affected his understanding of color. Jensen has said of himself, "[I] invent, arrange, dispose and organize color into a form worthy of a work of art."[6]

Mrs. May joined Jensen in Paris as an art student in the fall of 1927. Shortly thereafter, they fell in love and remained together until Mrs. May's death in 1951. From 1931 through 1951 they traveled together studying, painting and collecting. Jensen acted as Mrs. May's advisor during the years they visited the studios of many artists and acquired works by Bonnard, Giacometti, Gabo, Pevsner, Vuillard, Motherwell and Pollock to name a few; this collection later formed a substantial gift to the Baltimore Museum of Art, Maryland, Mrs. May's hometown. Using Paris as their base, May and Jensen traveled to the major cities of Europe. They would copy the works of the old masters and then return to Paris with the drawings for their teachers' criticism. Dufresne was to become Jensen's true spiritual mentor. He remembers wryly that Dufresne encouraged him constantly with the words "c'est pas mal."

Jensen established residence in the United States in 1934, and after that, with the exception of the war years, he and May traveled frequently to Europe. He was particularly moved by a trip to Holland in 1938, where he saw the paintings of Rembrandt and Van Gogh. Van Gogh's directness, purity of color and thick paint application must have felt very right to Jensen.

When Jensen traveled to Paris in the late 1930s he became especially interested in the writings of Auguste Herbin. Jensen saw Herbin as one of the new spiritual leaders of abstraction in Paris; Herbin's writings, inspired in part by Goethe's *Zür Farberlehre,* reinforced Jensen's acquaintance with the German poet's ideas. After seeing an exhibition of Herbin's work, which included some paintings done on the basis of the spiritual interpretation of letters, Jensen wrote, "He strengthened my determination to understand Goethe. Goethe is very complex. It took so many years."[7] In fact, Jensen was inspired at that time to begin a study of Goethe which would occupy him for the next twenty years. In 1938 Jensen and Mrs. May visited André Masson. Jensen was as intrigued with Masson as he had been with Herbin; Masson's interest in psychology, Freud and Surrealism, coupled with the fact that he had been a pupil of Juan Gris, particularly attracted Jensen.

Surrealism came after [the] Cubists worked with pictorial plane and showed it could suggest a composition like [Picasso's] Three Musicians. Then it was translated into the idea that a plane could suggest dreams, passion, violence, fantasies and anecdotes that became part of the suggestibility of the picture plane.[8]

Thus, Alfred Jensen had the benefit of a unique education. When Saidie May died in 1951 Jensen settled in a studio in New York City. Arriving in New York in the early 1950s Jensen was witness to the very beginnings of the American avant-garde movement and the New York School. Museums had just begun to recognize and exhibit the work of Newman, Pollock and Still; their work had previously been shown only in the adventurous galleries of Peggy Guggenheim and Betty Parsons. By the mid-1950s it was a mixed and interesting scene. Josef Albers was painting his "Homage to the Square" series, Pollock was working on a group of black and white stained canvases, de Kooning was well along with his famous "Women" series, and Rothko was making paintings in what is considered to be his mature style. There was a second generation of artists beginning to emerge; among the most interesting, Frankenthaler, inspired by Pollock, was experimenting with techniques of staining the canvas, and Jasper Johns was just beginning his "Numbers" and "Flag" paintings. Allan Kaprow, Oldenburg, Rauschenberg and Segal were among the artists beginning to involve themselves with the objects and activities of popular culture.

Jensen found himself in an unusual position. Neither as far along in his development as Still, de Kooning or Newman, nor as young as Kaprow, Johns and Oldenburg he was in his own words:

. . . sort of a messenger between the older and the younger generations. I found myself in between. The older generation wouldn't accept me because they felt I hadn't deserved the place to be counted amongst them, and the younger generation was eager to be inspired by my past knowledge, of Parisian painting and [by my] present knowledge, by association, of the older artists. My relations with the younger artists were always very cordial. I brought the European attitude that the older painter should aid the younger ones, but here, when I talked to them [the older artists], they said they were afraid to associate with them [the younger artists]. So by that I was the messenger.[9]

It was during these crucial years in New York that Jensen's own personal style developed and emerged. In formal terms Jensen's work of this period related only briefly and tangentially to that of other artists; rarely did

his philosophical interests touch with those of other artists. Ultimately his development was truly unique. His work has always remained separate because it is founded on theories of color, mathematics, ancient cultures and science.

During his first six months in New York Jensen worked in isolation, having no communication with other artists. His work at this point had been "conditioned by French art."[10] Accustomed to going to museums and exhibitions and having made the acquaintance of so many artists when he traveled with Mrs. May, Jensen gradually entered the New York art scene. In 1952 at the *15 Americans* show, one of a series of important exhibitions curated by Dorothy Miller at the Museum of Modern Art, Jensen met Mark Rothko. Jensen remembers, "I assaulted him . . . for his lack of dualities." This strange beginning precipitated a long friendship and mutual exchange of ideas. Jensen, whose pictorial interests lay in representing universal conflicts and dualities, explained to Rothko what he saw as the conflicts between heaven and earth as they related to consistent and inconsistent laws of physics. Rothko, in turn, told Jensen of his childhood in Russia where, as a Jew during the pogroms, he was forced to watch the diggings of huge common graves and how that rectangular shape came to occupy his paintings. "It was," Jensen says, "a constant battle between [my] dualities and [his] presence." Stylistically the two artists shared at most an interest in large areas of flat color; more importantly they shared a common pursuit of a personal vision.

Jensen's first exhibition in New York was in 1952 at the John Heller Gallery on 57th Street. The show of twelve paintings included still lifes, landscapes and some portraits in what Jensen refers to as "abstract colors." Between 1954 and 1956 Jensen exhibited in three group shows at the Stable Gallery. In one such exhibition his work was hung next to that of Franz Kline in a show that also included Cornell, de Kooning, Rauschenberg and Cy Twombly. This, Jensen feels, was his real introduction to the American avant-garde. With the Pop artists, Oldenburg, Jim Dine and Segal, Jensen exhibited at the Ruben Gallery in 1953. It was there that he made the acquaintance of Allan Kaprow who had also been a student of Hans Hofmann. Jensen says of Kaprow:

He dealt in numbers before I began dealing in numbers and that interested him – that I could find another way of structuring numbers that he hadn't thought of. He was an existentialist and I was not. It intrigued him very much.[11]

Kaprow, who was involved at the time with making Happenings, was a lucid critic and was one of the most astute commentators on Jensen's career and work. He wrote of Jensen in 1963:

At the same time as his younger colleagues, he found himself. His deep feeling entered a fertile relationship with a carefree esprit of bravado. I still consider him a teacher and a contemporary. His insight and his work have steadily been growing and always a new, large river of new thoughts flow – visions seem to flow over him, of new discoveries, new connections, to old ideas that have been floating around, and always with the enthusiasm and conviction we associate with youth. Though Alfred Jensen is older than my contemporaries, he seems to be younger, a cousin rather than a father figure. [12]

The artists to whom Kaprow refers were struggling with the past. Jensen too was sharing their rejection of gestural painting. Jensen recounted sympathetically Rothko's experience on a trip to Europe. Rothko found the only paintings in Europe he could admire were those of Fra Angelico "because all the other painters had foreground, middleground and background — they were all about gesture." Jensen's development was relatively free of conflict — he was not troubled by the problems the object-oriented artists had with Abstract Expressionist traditions or by the earlier Abstract Expressionists' attempts to throw off the yoke of European influence. "I have the European and American schools — they blend in me," said Jensen. For Jensen, unconcerned with taste and style, information could be mastered only through color and number.

Jensen's work exhibited in the early 1950s was typified by large areas of heavily impastoed color. Jensen had never seen the blank canvas as a void onto which he could pour his emotions. He was a personal painter, but had never been an emotional one. The paintings directly preceding the earliest one exhibited in this show, while still expressionistic, hint at a breaking up of space by some means of patterning. Jensen was approaching a breakthrough which was to come in 1957. Since 1944 he had been making notes of his readings and studies, in the form of drawings and paintings on paper or matboard, which he called diagrams (inspired by and named after Goethe's term for his own color studies). These drawings, with their handwritten notations, were responses to many things — for example the ideas presented in the writings of Goethe, Leonardo, Shakespeare and Nathanael West; others were studies, such as those of the sun as it

came through the window of his 10th Street studio. Jensen had these diagrams pinned up everywhere. The diagrams were investigations into all sorts of visual information and phenomena; they were executed very rapidly and directly. Jensen now uses them as preliminary material to work out paintings, "they are the logic of the paintings," but before 1957 they were studies, not stylistically connected to his paintings. Explaining his breakthrough of 1957 Jensen said:

I got rid of my expressionistic paintings entirely and became a diagram painter – that's the way it happened. I developed my study into a style. I [had] considered these researches as studies. I had unconsciously done my style for 10 years without using it. That's very important because I have always been asked, "How did you develop your style?" [13]

By 1957 Jensen had completely rejected the possibilities of working in an expressionistic or gestural manner. "I had said goodbye to the abstract expressionists per se. I believed in the great abstract expressionists but I didn't believe in the followers, so I didn't have anything to do with it. I wanted to express my individual style." [14] At that time Jensen spoke of the need for an analytical art, "because synthesis is important for the spectator as well as the artist." [15] The Abstract Expressionists criticized him "for talking shop . . . for talking like a concierge." [16]

Having "discovered" his style, Jensen moved rapidly towards incorporating the information from his studies totally into his paintings.

In *My Oneness, a Universe of Colours* (1957), the earliest painting in the exhibition (its format is derived directly from the diagrams), a single central image dominates. This image is a thickly, almost crudely painted circle of concentric rings of color, alternating light and dark. The painting is, as the title implies, about Jensen's world — the world of color. For Jensen the circle (the universe) is female: "The circle — containing and continuous, the fortune belongs to woman." [17] In this painting the circle is visually confined by the square edges of the canvas. The circle within the square presents the metaphors for both female and male. "The square — rectitude, uprightness, balance and the willed joining of 2 halves squared again belongs to men." [18] The circle and the square appear together or individually in almost every future work — representing the most basic of opposites. As in the diagrams, which almost always include written notations, Jensen inscribed a quote from Shakespeare at the top of this picture: *So we'll live and pray and sing and tell old tales and laugh at gilded butterflies.* The words are from

the death scene of *King Lear.* Thus, Jensen is offering us a symbolic juxtaposition of the eternal circle with a written reminder of mortality. Below the painted circle, Jensen has written *Self Identity* and *Self Integration.* For Jensen the most important aspect of artistic investigation is the discovery of the primary idea and its subsequent integration; the result is an assimilation of that idea into his vision, of the order and logic of things, and into his art. At the bottom of the canvas appears a quote from Nathanael West: *No repeated group of words would fit their rhythm and no scale could give them meaning;* this reference applies more specifically to the formal elements of Jensen's art. It is similar to his having copied from da Vinci, in a group of works from 1959 entitled *Homage to Leonardo da Vinci and Goethe,* onto two paintings respectively, *There is nothing in a painting more useful and necessary than the setting down a simple foundation of colours* and *After Black and White come Blue and Yellow, then Green, and Tawny and Umber, and then Purple and Red. These eight colours are all that nature produces.* This choice of inscriptions hints at how Jensen incorporated what was previously purely a study with the formal elements necessary to build a painting. As indicated, also by the quotes, Jensen's primary interest was, at this time, color. Following Goethe's example Jensen was using the prism to investigate color. He has said of the prism:

> [The] *brilliant display of light seen through a prism displays a labyrinth of beauty. A simple object representing a game, first fascinates, extends the present, then leads to ordered study revealing a new world . . . I knew that the prism held the clue that would enable me to arrive at the understanding of the genesis of color.* [19]

The diagram *A Prism's Light and Dark Spectral Action* (1957) illustrates the way in which Jensen arrives at both the concepts and the images of his iconography. In actual and visual terms, the prism allowed Jensen to experience color while at the same time, intellectually it offered him the means to invent the checkerboard image. Looking through the prism Jensen discovered the existence of the light and dark ends of the spectrum — which he referred to thereafter as the white prism and the black prism. The transition from black to white found within the prism suggested to Jensen the image of a checkerboard, "the alternating rhythms in light and darkness. This physical ordering reflects the cycle of man's destiny." [20] Jensen's understanding of the prism revealed to him certain concepts as well as certain images. *A Prism's Light and Dark Spectral Action* is explained by its inscription: *A*

diagram used as evidence serving to reveal the finite and completely determinable function of a prism's light and dark spectral action. The diagram is divided in half — painted white at the top and black below — over which two triangular bands link to form a diamond shape (even the profile of the prism gives validity to the triangle as a pictorial shape). Black and white blocks bisect the perimeters of the bands, representing the two ends of the spectrum as observed through a prism. This formal visual ordering of his perception illustrates Jensen's arrival at the checkerboard image. His discovery of prismatic color (Jensen's term) and the resultant checkerboard image are two important parts of his visual vocabulary.

For Jensen black and white were not necessarily the only possibilities for the checkerboard — they could, in fact, be implied because he saw "color as the struggle between black and white. Colors are the children of black and white. The children of black are blue, green and violet; of white — red, orange and yellow." [21] The checkering process suggested by the prism formed the basis for *Tattooed* (1958). A checkered ground of four colors — blue, violet, red, yellow — and black and white holds a central but free-floating configuration of nine checkers overlaid by a black half circle. The form, made by the pairing of a circle (female) and a square (male) suggests a house.

Galaxy I and *Galaxy II* (1958), a two panel painting with each panel enclosing a central sphere, further explores the possibilities of the circle. The spheres, painted in red, yellow, black and white irregular bands, are split horizontally and re-paired. Color in this painting can be seen as the metaphor for light and dark. Jensen has written:

> *Light travels in circular wave shapes. The Darkness forms intermittent circular wave shapes. Therefore no void actually exists . . . We are one with creation.* [22]

The circle, split and re-paired again, can be self and wholeness. Another reference suggested by the painting's title, to the earth's horizon line where there is the possibility of seeing half of the rising or setting sun, refers to the correspondence of the planets to one another.

Jensen's interest in planetary influence as it orders the universe is expanded upon in his later work. It is reflected in *A Glorious Circle* (1959), a painting which Jensen refers to as a worship of the sun. The painting is made of up of four panels which are identified by the letters *N*(orth), *E*(ast), *S*(outh), and *W*(est) as well as by the words *up* and *down* in alternating sequence, which suggest the rising and setting of the sun. At the top and bottom are bands made up of pairs of black and white

triangles suggesting the prisms from which the painting's color is derived. In this painting there is, for the first time, a noticeable change in Jensen's handling of the paint; the edges where colors meet are sharper but, more importantly, Jensen has carefully layered the paint to make a three-dimensional surface. The painting, however, still reads as being totally flat. The visual and conceptual nature of this phenomenon suggests a map.

Revolving Spheres (1959) is the last of this early group of works devoted primarily to the prism and the checkerboard. Illustrating the theory that "warm colors are formed on the black mirrored surface of the black checker . . . cool colors are formed on the white mirrored surface in the white checker,"[23] Jensen has painted five spheres of rotating color on a large black and white checkerboard. The eternal checkerboard gives life to the circles of color.

Square Beginning — Cyclic Ending, Per I, 80 Equivalent Squares of Value 5, Per II, 48 Equivalent Squares of Value 5, Per III, 24 Equivalent Squares of Value 5, Per IV, 9 Equivalent Squares of Value 5, Per V, 1 Square Area of Value 5 (1960) introduces mathematics into Jensen's pictorial vocabulary. Jensen's study of ancient China's numerical system, which is based on five, provides the actual source for this painting. Numbers are, of course, suggested in the earlier work. For example, Jensen has written:

The unit in the form of a number is symbolically the expression of the ultimate oneness of being, but it is arrived at after believing in the very beginning was Half. Men is one half — women the other half. Joining the two halves makes ONE. The number 2 means 2 halves. All multiples of 2 are feminine. All odd numbers are male. Their involvement (male/female) spell out the rhythms of life – corroborated by the appearance of the movements of the stars and the seasons and forms the basis of philosophy, religion and art.[24]

Through this example, it is possible to understand the way in which Jensen's thinking layers ideas one on top of another. He may choose to make a painting *about* one of his ideas but to actually make it he uses signs and symbols which carry into each painting the suggestion of many other corresponding or opposing elements.

Square Beginning — Cyclic Ending, reflecting the same delicacy of surface found in *A Glorious Circle*, is a five panel painting; each square depicts a multiplicative cycle of the number five. Jensen's personal ordering of the universe (represented by *My Oneness, a Universe of Colours*) responds to the ordering of the universe by the ancients. He had learned that:

The view of the ancients was that the universe and nature are essentially arithmetical and was expressed as a purposive interactivity between concepts of unity and multiplicity.[25]

Each panel is broken into squares of color, containing a Chinese numerical symbol, on top of which is a grid set inside a circle which rotates slightly from panel to panel. The painting anticipates both Jensen's later and fuller involvement with ancient Chinese culture and his commitment to number as a necessary element in the making of a painting.

In a painting I can achieve a sensation because as I paint I show the visual in its reciprocal relationships, at interplay and acted out between neighboring number structures. I also show that interplay exists between number and color area.[26]

Two 1962 paintings, *The Light Color Notes* and *Sixty Keys*, amplify the multiple roles of color in Jensen's work. Each picture belongs to a larger group of paintings on the same theme. The relationships and correspondence of number to color relies on the specific intent of each painting. Jensen's use of a mathematical system is determined by the concept he wishes to illustrate.

Conventional abstract numbers when used in the associative manner are not employable in my way of arriving at the truth. . . .[27]

Returning to the prism and incorporating corresponding scientific references, Jensen painted *Aurora, Per VI Motion in Coloristic Orbit* (1961); its title refers to the atmospheric, probably electrical, phenomenon which radiates from the earth's northern (or southern) magnetic pole — i.e. the aurora borealis. It suggests Jensen's interests in scientific explanations for the appearance of color in nature. His interest in this relationship reappears in *East Sun. Perpetual Motion* (1963). The perpetual motion of the planets was a constant which suggested to Jensen a parallel with the consistency of other laws of nature. He extended this investigation to include color when he wrote in a letter to his dealer, E. W. Kornfeld:

When I write about color I liken its energies to the discovery of the order of the circulation of fluids, similar in nature to the study of electricity and magnetism. We know the induction of positive electricity into negative electricity represents 'fluids.' We also know that the magnetic induction is from the positive to the negative outside the magnet, and from the negative pole to the positive within the magnet, so the lines and tubes of induction are re-entering or

*cyclic figures. We, as well, know that when light is
turned from its inherent direction and reversed,
it is said to be polarized. This knowledge I use as
applied to color.* [28]

In *East Sun. Perpetual Motion* the arrows and plus and
minus signs are clearly identifiable as the forms which
imbue this painting with scientific references; these
references serve to give added meanings to black and
white as well as to the circle and the square.

Jensen's frequent references to "the ancients" reflect
his desire to discover the original sources of ideas which
he finds correspond to those he already knows. *Men and
Horses* (1963), one of the greatest of the checkerboard
murals, takes its figures from the Parthenon frieze. The
figures, painted in checkers of violet, green, blue, yellow
and red, are set against a ground of black and white
checkers. The right and left sides of the canvas are banded
with two color strips — blue and white on the left and
black and red on the right. These strips serve to
emphasize the flat banner-like quality of the painting.
Spatially the picture is unique — it suggests figure and
ground but without any protrusion or recession within
that space. The eternal motion and three-dimensionality
of the horsemen frozen by the Greeks in their
two-dimensional relief has been re-frozen by Jensen in the
checkerboard pattern on the flat canvas.

Jensen's trip to the Yucatan, coupled with his readings
on Mayan culture — whose number system, based on a
multiple of five (twenty) recalled that of the ancient
Chinese to him — resulted in his incorporating several
new ideas into the paintings.

Through the mathematics of the planets Jensen
explored ancient agricultural and architectural structures
of Greece and Central America.

*The temples and pyramids portray the sun and the
planets in their calendrical permutations . . . These
measures of time still remain visually fixed as building
form and help make universal this monumental art.* [29]

This use of planetary mathematics as an architectural
determinant forms the basis for the iconography of
paintings from 1964 to 1970. These paintings incorporate
no referential symbols. They are bars, bands, blocks or
checkers of color. Of these pictures Jensen said:

*I use multiplication, addition, subtraction in painting
a picture. I use this method because the square gives
me the means of setting boundaries. I find in the
square specific settings, divisible areas, number
structures, possibilities of time, measure and rhythm
as well as the essential form of color which can be
placed in the square to interplay with number forms.* [30]

Jensen likens the reading of the expansion from or

contraction towards the center of these canvases as the
image analogous to the visual sensation experienced
when flying from Guatemala City to Takal:

*You have the burned out forehills and then you go
further and you have the cultivated coffee plantations.
And then all of a sudden you get into the rain forest.
You've got all the growth.* [31]

The actual paint application to these paintings reflects
Jensen's involvement with measures of time. The daubs
of paint — tiny checkers — applied directly from the tube
mark time like the ticks of a clock across the face of
the canvas. Kaprow remarked:

*Spatial extension in any direction is exactly measured
by giving the eyeballs a periodic movement, square
by square, moment after moment.* [32]

The direct result of the movement of the planets is the
change of seasons. *The Sun Rises Twice* (1973) celebrates
the polar gnomen. Jensen once again returned to the circle
in the square image — the male and female designates of
life forces — here expanded to specifically represent
the earth (the right side) and the seasons at the southern
hemisphere (the left side). *A pole painting gnomen,*
written in the small center circle in the center of the
left panel, alludes to the ancient Chinese method of
measuring sunlight according to the tilt of the earth on its
axis in summer and the reverse tilt which occurs in the
winter. The gnomen and the subsequent realization of the
equinox is most fully explored by Jensen in *The Earth's
North-East-South* (1974).

I observed it [the earth's tilt] *the whole year — by the
sun moving northward and southward in the east. It
never apparently touches the west.* [33]

The paintings of 1975 are identified by Jensen's
interest in theories of the 19th century English scientist
Michael Faraday:

*The para-magnetic attracts the positive electricity
while the dia-magnetic attracts the negative
electricity. As an artist I employed Faraday's
deduction by using his law in terms of a visual
prismatic relationship backed by the concept of his
field theory.* [34]

For Jensen, already intrigued with the visual
possibilities of energy, reading Faraday gave him the
inspiration to combine magnetics and color in the
paintings *Physical Optics* (1975) and *Electromagnetic
Charge* (1975). The latter is made of two paired irregular
circles one above the other, representing the positive and
negative poles. Black and white arrows originating in
the centers of the circles point outward to indicate the
scattering and displacement referred to in the inscriptions

Electric field lines charged/after being displaced and *Scattered by a charged particle. Physical Optics* deals with energy and the perceptual theories of optics and in *Mr. Faraday's Diagram* (1975) the spheres through which the colors of the prism are conveyed suggest rings of positive and negative charges.

> *My work is done by a method of induction (charge) thinking. It is done by conceptions being placed side by side in patterns, and of magic things that influence one another, not by acts of mechanical causation, and which coalesce when they resonate.* [35]

Solar Energy Optics (1975) further interprets Faraday's ideas about vertical and horizontal magnetic theories. As in *Negative Optic Electric Force, Positive Optic Electric Force* (1975) positive and negative charges refer to vertical and horizontal visual relationships. *Solar Energy Optics* is a vibrant red painting of three panels. The left and right sides contain a checker pattern of diamond shapes. That pattern is reiterated in the central panel around which is written *Magnetic forces from the Sun's four separate magnetic fields oscillates. In that way an electric field registers Solar Energy.*

Asked how *The Family Portrait* (1975) related to the work he was doing on Michael Faraday and solar energy, Jensen replied,

> *It is a side trip into the dualities, as Faraday saw the physical realities of positive and negative electricity, so the everyday life is the positive and negative actions of the family, the father and son and the mother and daughter. It is a personal set-to between myself and the family. I painted it and I got the answer.* [36]

During 1976 and 1977 with *A Place Value Component, Per I, Per II, Per III* (1976) and *The Sum of the Earthly Numbers is Thirty* and *The Sum of the Heavenly Numbers is Twenty-five* (both of 1977) Jensen, using the Chinese-inspired root number of five, interprets even numbers as earthly and odd numbers as heavenly. Each is painted in its corresponding colors — the five colors of the black prism for the odd and heavenly numbers and the five colors of earthliness, derived from the white prism, representing the even numbers. The basis of the arithmetic involved is the addition of the numbers 1, 3, 5, 7, 9 which equal 25 (heavenly) and 2, 4, 6, 8, 10 equaling 30 (earthly). Pertinent to both works is a statement Jensen made about a third number painting *A Place Value Component:*

> *... [it] is numerical but makes the numerical count with a spiritual significance. It conditions the numbers so they are not like in the market place — it's on a higher plane. It is not arithmetic, it is cyclic. The*

addition and so on only proves that the amount of checkerboards [not only] *relates to the numbers but gives them another significance. The square shape becomes quality rather than quantity of numbers.* [37]

Ultimately *A Divine Mission* (1976) embodies many of the conceptual, procedural and iconographical elements found in Jensen's paintings. Theoretically it is the representation of Confucius' attitude towards immortality. Incorporating the works of the ancient Chinese philosopher Fu Hsie, Jensen recalls religion's preoccupation with immortality. Dualities are suggested: mortality/immortality, heavenly/earthly, temporal/eternal. The past as it suggests the future represented by *A Divine Mission* and the future as constructed from the discoveries of the past represented by *Solar Energy Optics* are testimony to Jensen's intensity of vision. As explanation of the breadth of his vision Jensen offers this:

> *Specialization ends in self-destruction, so my mission as an artist is to put that over. I respond to the sensibility of my epoch. I don't predict things — the artist's message is faith in his own epoch. The artist is the predecessor to actual events and discoveries. I don't want results, I want the road.* [38]

Jensen's attitude, and thus his paintings, are truly unique. Jensen ceaselessly pursues his own studies with the attitude that "the more my time ignores me, the more the future receives me." [39]

Footnotes

1. Wieland Schmied, "Notizen zu Alfred Jensen," *Alfred Jensen* (Kestner-Gesellschaft, Hanover, 1973), p. 20.

2. Christopher Crosman and Nancy Miller, Interview with Alfred Jensen (Glen Ridge, New Jersey, 6 April 1977), videotape.

3. Alfred Jensen, "Statement,"*It Is* (New York, 1958), p. 15.

4. Conversation between Alfred Jensen and Irving H. Sandler (New York, 21 March 1957), unpublished, n.p.

5. Ibid.

6. Crosman and Miller videotape.

7. Regina Bogat Jensen, Interview with Alfred Jensen (Glen Ridge, New Jersey, August 1977), unpublished, p. 8.

8. Conversation between A. Jensen and I. H. Sandler, n.p.

9. R. B. Jensen, p. 31.

10. All quotations from Alfred Jensen, unless otherwise noted, were in conversation with the author, 1977.

11. R. B. Jensen, p. 32.

12. Allan Kaprow, quoted in Leila Hadley Musham, "Alfred Jensen: Metaphysical and Primitive" (New York, 1975), unpublished, p. 22.

13. R. B. Jensen, pp. 23-24.

14. Ibid., p. 25.

15. Linda L. Cathcart and Marcia Tucker, Interview with Alfred Jensen (Glen Ridge, New Jersey, 30-31 March 1977), unpublished.

16. Ibid.

17. Leila Hadley Musham, "Alfred Jensen: Metaphysical and Primitive" (New York, 1975), unpublished, p. 36.

18. Ibid.

19. Ibid., p. 8.

20. Ibid., p. 9.

21. In conversation with the author.

22. Crosman and Miller videotape.

23. Musham, p. 10.

24. Allan Kaprow, "The World View of Alfred Jensen," *Art News,* December 1963, p. 29.

25. Musham, p. 34.

26. A. Jensen, "Explanations for a Friend and Artist," *Alfred Jensen: The Aperspective Structure of a Square* (Cordier & Ekstrom, Inc., New York, 1970), n.p. Text based on a letter from Jensen to Allan Kaprow, 24 September 1969. Reprinted as "Jensen Mikro Makro," in *documenta 5: Internationale Ausstellung* (Museum Fridericianum, Kassel, 1972) and *Alfred Jensen* (Kestner-Gesellschaft, Hanover, 1973).

27. Crosman and Miller videotape.

28. Letter from Alfred Jensen to E. W. Kornfeld, 20 January 1963. Reprinted in facsimile in *Alfred Jensen: Ausstellung von Ölbildern* (Kornfeld & Klipstein, Bern, 1963), n.p.

29. A. Jensen, "Explanations for a Friend and Artist," n.p.

30. Ibid.

31. R. B. Jensen, pp. 8-9.

32. A. Jensen, "Explanations for a Friend and Artist," n.p.

33. R. B. Jensen, p. 37.

34. Ibid., p. 36.

35. A. Jensen, "About My Work," *Alfred Jensen: Recent Paintings,* (Pace Editions, Inc., New York, 1973), n.p.

36. R. B. Jensen, p. 38.

37. Ibid., p. 39.

38. Crosman and Miller videotape.

39. Ibid.

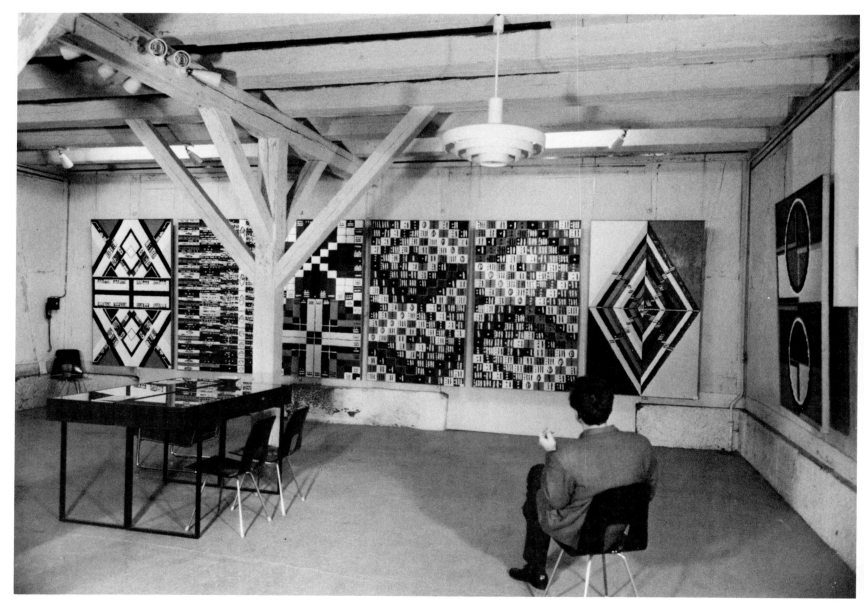

Installation view of *A Quadrilateral Oriented Vision* (1960)
at Kornfeld & Klipstein gallery, Bern, 1963

Mythic Vision: The Work of Alfred Jensen
by Marcia Tucker

In language, in religion, in art, in science, one can do no more than to build up one's own universe – a symbolic universe that enables us to understand and interpret, to articulate and organize, to synthesize and universalize our human experience. Ernst Cassirer[1]

I

There is a haunting poetry in Alfred Jensen's work which defies analysis. The work seems simple — flat, thickly painted checkerboards of bright color, numbered or bordered with obscure scientific symbols or equations, bands of lush, heavy color, geometries and patterns that are somehow familiar, classical. The paintings call to mind Persian rugs, gameboards, tiled floors, Tantric diagrams, illuminated manuscripts and medieval stained-glass windows. Entering Jensen's studio, one is struck by the radiance, complexity, multiplicity of pattern and hue of the paintings; the light which emanates from them is stronger, somehow, than any other kind of light. The effect of the paintings, like the process by which they are made, is cumulative, so that the visual world outside the paintings becomes, slowly, subsumed by them. They are so strong that they constitute their own world against which "real" things pale — not only a visual world, but a theoretical and philosophical one as well.

Jensen has been called a "metaphysical" artist, an "abstract Primitive," "the abstract Rousseau," an idiosyncratic and eccentric artist. "People think I'm a mystic," he said in recent conversation, "but I'm not."[2] Jensen's discussion of his own work, both written and verbal, is fascinating, complex, difficult to follow, and extraordinarily erudite. To those accustomed to explicating works of art by means of a formal, aesthetic vocabulary, much of Jensen's scientific and ideological explanation can be intimidating or simply incomprehensible. His conversation covers an incredible range of arcane and abstruse information — solar cycles, Mayan and Peruvian calendars, Egyptian pyramid builders, the discoveries of 19th century scientists like Faraday, Oersted, Minkowski, Maxwell, and Lorenz; the theories of Leonardo, Goethe, and Pythagoras; the science and technology of ancient China, the *I Ching*, magnetic forces, sub-atomic particles, space travel, the optics of the prism. Jensen's thinking and knowledge are layered, inclusive, relational. He is interested less in isolated instances than in the correspondences between things of different natures. He is fascinated by systems and ways of ordering that join and unify dissimilar elements.

Although the overall effect of his paintings is poetic, Jensen, as his long-time friend Allan Kaprow wrote, reveals through his work the existence of more than an intuitive search for the underlying form of things and their aesthetic laws.[3] In general, astute critics of Jensen's work have found its ultimate aim, if not its effect, to be that of a universal world-view, an all-encompassing order, an archetypal structure.[4] Jensen himself is quoted as having said that "it is poetry of the painting in the long run, the inner vision, that must be appreciated by the viewer."[5] It would, indeed, take a lifetime of study to assimilate the amount of knowledge that Jensen has accumulated throughout his career.

Jensen's background is as intricate and colorful as his work. Born in Guatemala in 1903, he lived in Denmark as a child, then in San Diego. He studied abroad, first in Munich with Hans Hofmann, then in Paris. He traveled widely, first visiting Australia, Singapore, and other ports as a sailor in the early 1920s, and then, from 1929 to 1951, living abroad with his companion Saidie May. They spent many years in Paris, visiting Africa and Spain often. They were acquainted with such artists as Gabo, Miró, Matisse, Giacometti, Picasso, Motherwell, Ernst, Maillol, and Baziotes, and purchased their works, which were to become the core of the Saidie A. May Collection at the Baltimore Museum of Art. When Mrs. May died in 1951, on one of their trips to the United States, Jensen decided to stay and work in New York. At this time, his paintings were dark, swirling abstracts based on naturalistic shapes. It was not until 1957, under the influence of the writings of Goethe and Leonardo, that the characteristic "checkerboard" paintings first took form.

Jensen describes himself in terms of his activities: he has been a seaman, a farmer, a cowboy, a scholar. In 1965 he became a father for the first time. He and his wife, the painter Regina Bogat, have two children, and live and work in New Jersey.

Jensen's studies began in the late 1920s, under the tutelage of Mrs. May. "She got me to study the philosophers, science, and psychology. She locked me into a prison of education, and competed with me in painting,"[6] he recalled. Jensen is an avid reader; his studio is crammed with books on diverse cultures, scientific studies, astronomy, and mathematics. A small, wiry man, he is animated and articulate; he has a wry sense of humor, meticulous taste and a warm, volatile disposition.

Jensen's attitudes toward his own work, in addition to being influenced by early impressions of his birthplace, Guatemala, were altered and clarified by his frequent encounters with well-known and influential artists. He recalls that Dubuffet came to his New York studio in the

early 1950s, and said, "Now I know what puzzles me so much about your work. You have no taste. That's good!"[7] Jensen had studied with Hans Hofmann, although he disagreed violently with his teaching methods, disliking Hofmann's habit of painting over his students' work. He found him "too restrictive, too theoretical, too teutonic."[8] When he left Hofmann's school, he joined the Académie Scandinave in Paris and studied with Charles Dufresne and Othon Friesz. Charles Despiau, a sculptor teaching at the school during that time, was an important influence, more for his conviction about Jensen's talent than through any direct stylistic impact. Despiau urged Jensen to recognize the primitive aspects of his own sensibility and to reject the tendency of the French to traditionalize, intellectualize, and civilize their art. Ultimately, Jensen's need for a more immediate, "younger" sense of culture was responsible for his return to America.[9] His friends in New York in the 1960s included Mark Rothko, who, says Jensen, "built up my lack of presence and unity, while I built up his duality. It was a give and take." Sam Francis introduced him to Arnold Rüdlinger, director of the Kunsthalle in Basel, Switzerland, who in turn introduced him to Eberhard Kornfeld, in whose gallery Jensen's works were first shown in Europe in 1963. This was followed by a major exhibition at the Kunsthalle in 1964.

Although most of Jensen's art historical sources are in ancient cultures, such as the Greek, Mayan, Mesopotamian, Aztec, and Egyptian, Jensen's work visually has something in common with the Indian Tantric art of two hundred years ago, which, in its brilliantly colored geometries, also represents the basic divisions of Nature and the Universe, the measures of time and space, directions of the mind. Tantric diagrams schematize universal events, cardinal directions, male and female, dark and light binary opposites. They are also systems of incorporating many elements — numerical, astronomical, calendric, spiritual — with other dissimilar fields such as the physical sciences, architecture, and physiology.[10]

Jensen also had many discussions with Josef Albers about whether color is "true or false." Jensen recalls that Albers said, "What is actual about color resides in my brain; and therefore is my vision of color! And what consists of color in the outside world is temporal and is a matter to side with on what is seen by others." Thus, he says, their disputes ended.

Some interesting parallels exist with more recent sources, provided by Jensen's first-hand knowledge of European modern art. His work most immediately calls to mind that of the Orphists, a group loosely including the Villon brothers, Robert and Sonia Delaunay, Léger,

Chagall, and Kupka. Working in Paris between 1910 and 1913, the Orphists were devoted to the idea of proportion in sacred art, the harmonic relations between numbers, the prism, and the magical properties of light.

Jensen's ideas most closely resemble those of František Kupka, who was as much of an anomaly in those years as Jensen is today. The lack of linear progression in Kupka's work, his awkwardly impastoed surfaces, and his belief that art should express the order of the cosmos, are reflected in Jensen's concerns. Like Jensen's, his work utilized simple geometric forms, the entire spectrum of colors, and a highly patterned flat surface.[11] Kupka was known as a mystic and shared with such contemporaries as Robert Delaunay and Vassily Kandinsky an interest in analogizing art and music. Jensen, however, says that he was influenced not by the Orphists or by Kupka, but by the writings of Michel Eugène Chevreul (1786-1889), the French color theorist who wrote *The Principles of Harmony and Contrast of Colors and Their Applications to the Arts* (1839). Delaunay was strongly influenced by Chevreul, and Jensen feels that he and the Orphists are connected only by this bond; he is insistent upon focusing on such original sources rather than secondary ones.

The relationship between Jensen's concerns and those of younger artists is somewhat tenuous, although he is greatly admired by many of them. Jensen's incredibly complex multiple systems of pictorial ordering, combining knowledge and universalizing it, separate his work from that of artists of the 1960s and 1970s, inasmuch as Jensen's systematization is not only visual but theoretical, ideological, spiritual, and philosophical as well — elements which in his view cannot be separated. He has persistently refused to ally himself with any school or movement. Nevertheless, in purely formal terms, rigorous mathematical formulae have something in common with the organization of Sol LeWitt's cube structures of the 1960s, Donald Judd's serial sculpture, Larry Poons' early dot paintings, and Mel Bochner's physical mathematization of forms. There is also some visual relationship as well between the 1962-1963 stripe paintings of Frank Stella and the paintings of Jensen (of various years) based on the rectangle.[12] But Jensen's brilliant hues and thickly impastoed paint distinguish his work from that of the formalist painters of the 1960s. His work can also be distinguished from that of contemporary artists who use number in their work. Hanne Darboven and others use numbers as finite systems, to be read in the way that language is read, although generally the use of language is a more common manifestation of non-object or "conceptual" art than is number. Jensen's intentions are completely

different: he uses numbers magically, mythically, and symbolically, rather than, as in Darboven's case, as "a way of writing without describing."[13]

Perhaps more pertinent in terms of Jensen's influence is the emergence of a group of decorative or "pattern" painters in the past few years. Their flat, complexly patterned and colorful paintings refer back to a pre-Symbolist tradition, and have an affinity to Byzantine mosaics, Persian decorative motifs, Arabic and Islamic tiles.[14] But here again, Jensen's use of motif is incidental to his intent, which is clearly spiritual and philosophical, although some of his paintings seem at first to be more purely decorative than others. In this exhibition, some of the earliest works, like *Tattooed* (1958), *Magic Colors* (1959), or *Eternity* (1959) rely more than later ones on the juxtaposition of repeated color and shape without the incorporation of numbers, letters, or symbols. However, one late painting, *Taj Mahal* (1975), utilizes the repeated motif of a shape from an Indian screen, in which figure and ground repeatedly reverse themselves. This is the closest Jensen comes to making a completely decorative painting. Although the use of clear, prismatic colors and repeated motifs are characteristic of his work, the underlying structure is densely complex, and his intentions are always to reveal meanings with more than a visual dimension.

Jensen's earlier paintings consisted of dark, swirling abstract forms, but his mature work dates approximately from 1958. From this point on, no linear progression can be traced in the work, no "evolution" of style as is usually the case with artists. Jensen's paintings increase in theoretical complexity through the years, but their form remains relatively stable: numbers, words, and symbols; flat, repetitive geometric configurations — circles, diamonds, squares, triangles, rectangles; checkerboard patterns of colored squares and dots; colors juxtaposed in elliptical or rectangular bands; polyptych, multi-panel works in which, for each configuration, the obverse is presented — all these are unchanging elements in Jensen's work.

Described by Jensen as "a continuous oscillation between numerical and prismatic concerns," his paintings are a sustained dialogue between a sensuous, expressive, deeply poetic use of pictorial elements, and investigations into non-aesthetic systems of knowledge upon which the sensuous elements are based. Motivating his investigations is the drive, like that of the scientist, to find order in phenomena.[15] "Research, synthesis and observation has always been my method of working."[16] He notes, for instance, that he has studied "the psychology of the eye as well as its physical nature." According to Jensen, the impulse for his system of ordering comes "from the

psyche, which decides what it's all about. It has nothing to do with nature, but with the psyche, so it's truth." The first checkerboard paintings came about, he says, because he had always been painting "phenomena" but now wanted to paint a mental image. He was prompted to do so by reading a book about the Mayan calendar. The resulting painting, which also owes something to a comment Rothko made about a work of art which "represented pure mind," was called *A Quadrilateral Oriented Vision* (1960). In the Mayan calendar,

> numbers are arranged on a square grid to make 'magic squares.' I read the book three times until I conceived the picture . . . which is a Katun or a chart of twenty years. It took months of figuring, and every area has a color according to a numerical value; the numbers are always in black and white because they are the father and mother of colors. I planned the painting for six months and painted the six panels in six weeks. When I arranged them in their proper sequence they composed a mental image of the calendar system. I have gone from phenomenal color to mental color.[17]

This description of one of the early mature paintings is a key indication of the way Jensen thinks about the amalgamation of diverse elements in his work. All elements have equal value — the complex mathematical structure of the Mayan calendar, the binary opposition of black and white which symbolized the generic origins of color, and the square as the ideal symbolic and magical format.

The acquisition of knowledge and its ordering in his work are a ceaseless process for Jensen. For the past three years, he has been preoccupied with "the battle between protons — neutrons and electrons," and has made an extensive series of drawings based on his investigations. Because his work does not "evolve" stylistically, he refers back to it constantly, picking up earlier concerns and reintegrating them in the light of new investigations. He is, understandably, reluctant to part with his own work. He believes that an artist should have a twenty-year range of work available in the studio for reference. He also feels that late recognition is important to an artist's development, because "it helps the digestion of visual values, and prevents a loss of self-identity." Thus Jensen creates a world through his work which is uniquely his own, a complete, self-referential system in which all the knowledge and information available to him can be incorporated, contained, and presented.

Jensen's amalgamation of so many kinds of information from disparate and arcane sources, his life-long attempt to combine and unify them in a single pictorial system, and

the origination of this work in profound personal conviction and feeling, constitute a heroic attempt to infuse each work of art with all the knowledge and feeling available in the world.

II

Space, Color, Light

Jensen's work is immediately characterized by its flatness, by its lack of spatial illusion. Jensen's paintings have little to do with optical shifts and distortions; rather, they seem to present themselves first as strongly physical, tactile surfaces. Donald Judd, writing in *Arts Magazine* in 1963, noticed that

> *many of Jensen's paintings are thoroughly flat, are completely patterns. Jensen's paintings are not radical inventions but this aspect is. There are no other paintings completely without space.* [18]

This flatness is important, since it is a primary indication of Jensen's lack of concern with illusionism. He uses the simplest particulate geometries, arrayed according to increasingly complex numerical systems, to unify diverse elements into a harmonious whole. The formal configurations chosen by Jensen as best suited to sustain the work's ideological structure are classical ones, stable forms capable of expressing an all-encompassing *zeitgeist.*

Color is a major formal aspect of Jensen's work; he uses pure color, not mixed with gray, which ranges across the entire spectrum. Even his black and white paintings are luminous, visual assertions of his theory that black and white are the parents of all color. Jensen's two mentors, Leonardo and Goethe, are the subject of a series of 1957 paintings dedicated to them. One contains a quote from Leonardo: "There is nothing in painting more useful and necessary than the setting down of a simple foundation of colours. I shall place their subject between theory and practice."

Much of Jensen's own writing has to do with color theory, derived in part from Goethe and in part from pre-scientific and magical uses of color. These ideas are amalgamated with 19th century scientific theories of light, conceived in relation to electrical and magnetic currents. [19] Jensen's poetic attitude about the origin of color is similar to Goethe's. "When color is taken as a simple and independent determination (apart from the color of an object), it represents, as Goethe put it, "the acts and sufferings of light." [20] Jensen's color is

> *a result of a struggle between black and white – the children, as it were, of black and white. The children of black are indigo blue, marine blue, blue magenta, emerald green, red-violet, raw sienna; the children of white are red, orange, yellow, greenish-yellow, cerulean blue, ultramarine violet – twelve children, like the twelve tribes of Israel.* [21]

In unpublished letters to Henry Luce III, his friend and collector, Jensen explained a color-hue theory at work in *The Magician,* one panel of *The Golden Rule* (1959), a large mural owned by Luce. He describes a thunderstorm, which establishes a black mirror on one side of the atmospheric dome, while the sun establishes a white one on the other side. The interplay of both forces produces a rainbow. The prism structure consists of a twin mirror of black and white also, embodying in its crystal the atmospheric dome of nature. The ancient people, in their universal preoccupation with the double-mirroring process, regarded the prism as an instrument of divine origin, a curative device and an aid to mystical vision. [22]

The action of the prism is the basis of Jensen's color theory, as it was of Goethe's. All color emanates from light and dark, black and white. These polarities have specific meaning for Jensen: white is male, black is female; day is square and night circular.

Jensen has written of his alternating checkerboards:

> *This physical ordering reflects the cycle of man's destiny: the vastness of my former fears of darkness were resolved as I read first the dark square. I read second a light square, meaning first night, then day. The seasons I read, the years I saw appearing as images, the living followed by the dying in my checkerboard existence; and since every black is followed by a white, I found my place in eternity.* [23]

The opposition and cyclical rhythm of light and dark is a pre-eminent image. "The Light of Life. The Somberness of Death. The Color of Art. A designated pattern of a phenomenal existence, subject to Time," Jensen wrote in 1963. [24] In *The Marriage of Universal Darkness and Solar Light on Earth* (1975), Jensen pictorializes a universal concept; on a square canvas, three alternating grids of light and dark are arrayed so as to form a dark cross in the center, within which is another four-part grid of alternating light and dark squares, containing at its center yet another square, tipped to form a diamond with a yellow circle at its center. The diamonds and squares contain symbols for protons and neutrons, and consist of alternating black/white components, or color components which refer to their counterparts across the painting; each tiny square within a square refers to every other part of the painting, and is both its nucleus and its result.

Mythical Thinking

The symbolic use of light and dark is one of the basic factors in mythic thinking, where "the bursting forth of light out of darkness is the one original phenomenon." [25]

Light out of darkness is the subject of the Biblical creation; it is the foundation of the Babylonian belief that the world was created in imitation of the sunrise.[26] The interchange of day and night, light and darkness, underlies the basic human intuition of both space and time, and thus is at the root of all thought:

> We start from the assumption that sense of place and receptivity to impressions of light are the two most fundamental and deep-seated manifestations of the human intelligence. It is by these two roads that the individual and the race achieve their most essential spiritual development. It is from this perspective that the great questions have been answered with which existence itself confronts each one of us: Who are you? What are you? What should you do? . . . The progressive view of the difference between day and night, light and darkness, is the innermost nerve of all human cultural development.[27]

Jensen's view of reality parallels almost exactly this, the mythical view of reality, as it has been most extensively delineated by Ernst Cassirer in *Mythical Thought* (1925). Both views are dialectical: every aspect of human thought and activity is linked with another aspect of it, combining in series and ultimately subordinated to process and law. "In myth," writes Cassirer,

> all phenomena are situated on a single plane. Here there are no different degrees of reality, no contrasting degrees of objective certainty. The resultant picture of reality lacks the dimension of depth –the differentiation of foreground and background so characteristically effected in the scientific concept with its distinction between "the ground" and that which is founded on it . . . Above all, it lacks any fixed dividing line between wish and fulfillment, between image and thing.[28]

The spatial flatness in Jensen's work, the unchanging style, and the extraordinary mixture of systems, facts, ideas, and sources in his painting fulfill this definition. In Jensen's work, as in mythical reality, all things in the world are seen on a single plane. The corollary of this view is that nothing exists in isolation, that everything leads to something else. "Every new object, properly seen," as Goethe said, "opens up a new organ of sight."[29] Likewise, in the mythic world view, no real distinction can be made between fact and theory. For Jensen, as for Goethe, "all sight passes into contemplation, all contemplation into speculation, all speculation into combination, so that at every attentive glance into the world we are theorizing."[30] Thus, in 1964, Jensen wrote of his mother's death:

> My mother had died; and on a sunny afternoon I stood before the orange-colored oblong box ornamented with its kneeling silver angels, their praying hands each pointing towards the Cardinal Directions . . . I saw my mother's remains lowered into the darkness of the grave. By my side stood my two brothers and sister, all four of us being represented on the coffin's lid as images of angels . . . Preoccupied with my early encounter with the mystery of death, my painterly effects have centered around a square and a circular space with directional environments pictorially determined.[31]

For Jensen, in the particular event there is a universal meaning, which in his work he makes specific again. Symbolism, the interplay of light and dark, the cardinal points, unity of space and time, the systematization of differing elements, a profoundly spiritual consciousness and a strongly sensuous, visual awareness of events — the elements of his painting — are marked in this brief passage. Similarly, in a touching anecdote which prefaced his 1973 exhibition at The Pace Gallery in New York, Jensen described how his small son, Peter, first became aware of his own masculinity standing next to his father as they both urinated. Jensen uses this example to highlight the importance of "correspondence" between classes of things. This leap from an ordinary, basic event to the context of "high" art, so characteristic of Jensen — and inherent in mythical thought — seemed to many humorous and even shocking.

Jensen quotes his children often in his writing; in his introduction to the present exhibition, for instance, he notes that his son wrote, in a school essay, "My father is strong and good because he paints solar energy." It is one more juxtaposition of the ordinary and the abstruse that has prompted many critics to see Jensen as a primitive. However, this ability to see the general and the specific as interchangeable is indigenous to mythical thinking, which "reveals a process of schematization; as it progresses it . . . discloses an increasing endeavor to articulate all substance in a common spatial order and all happenings in a common order of time and destiny."[32] In mythical thought, the structure of an astrological world-view, of time as "a moving image of eternity,"[33] came about from observation of planetary motion, in which the sun and the moon, representing light and darkness, were worshipped as gods. Astrological references, not surprisingly, are found throughout Jensen's work, often translated into numerological terms. These are most evident in those paintings based on calendrical systems, like *Mayan Temple, Per IV, Teotihuacan* (1962) and *Mayan Mat Patterns Number Structures* (1974). Astrological interpretations of the universe assume the view of a pre-determined fate, a fixed or absolute form which lies

behind every occurrence or series of occurrences. Existence, in this view, is not the result of causal conditions, which are variable. Rather, the astrological view strives to reveal mysteries which are constant and apply to the individual as well as the universe.[34] The idea of revealing or discovering what already exists is very much a part of Jensen's attitude toward his own life and work. He interprets early scientific discoveries, seeks ancient truths, explores alchemical formulae, reads about the secrets of the pyramid builders, researches the methods and systems used to determine the proportions of the Parthenon — all part of his ongoing investigation and amalgamation of pre-existing knowledge.

The Sun Rises Twice (1973), is a major, mural-sized work, in which the months of the year, the seasons, the cardinal points, oppositions of positive/negative, black/white, and an elaborate system of color equivalences are all arranged on both a square and a circular configuration at the same time. This painting, and others of the same year, such as The Sum of the Square of the Houses or A Circumpolar Journey are magical, transcendent works which imply more than their visual beauty reveals. The use of astrological references expresses Jensen's concern with the ways in which nature is ordered and his impulse to interpret this order mathematically and pictorially at the same time. Jensen's lifelong interest in Babylonian culture is relevant, since mythic and mathematical language are first found in combination in Babylonian astrology, which divided the zodiac into twelve parts and identified the constellations. The Babylonian epic of Gilgamesh is an example of the anthropomorphization of the heavens, in which the deeds of the mythic hero correspond to the paths of the sun and moon through the stars.[35]

Astrology, in organizing the events of nature into a fixed system, also assumes that there are magical properties inherent in nature and in the ratios which can be discovered in it.[36] The establishment of any system or schematic mode is a creative and conscious act, and therefore intelligible to some extent as art. Interestingly, art generally seems to have been directed toward more or less magical aims in its origins, and these aims may persist even in its present-day manifestation,[37] especially inasmuch as art was initially a mode of representation, and only later became magical in part by virtue of the role of the artist as cultural prognosticator. The connection between the making of art and the astrological world-view may thus be that they share magical properties, and both attempt to establish a unified and coherent system of expression.

The ordering principles at the heart of Jensen's work are those of balance, equilibrium, or binary opposition. In his paintings, there is a constant interplay of polarities — light/dark, positive/negative, warm/cool, plus/minus, unity/multiplicity, male/female, heaven/earth — used for putting things in relation to each other, thereby into harmony. The titles of the paintings, their binary oppositions, and their paired panels suggest that for every existing image or state of being, there is an opposite and equivalent image or state, that all things have their numerical and visual counterparts. The grid system, square or rectangular, is especially well suited to the use of binary forms, because each image, number or color can be mirrored on a diagonal as well as on the horizontal and vertical axes. Thus, in Jensen's work, there are opposites within opposites and across opposites. Most of his work is based on a square configuration, whose use he describes:

I use multiplication, addition and subtraction in painting a picture. I use this method because the square gives me the means of setting boundaries. I find in the square specific settings, divisible areas, number structures, possibilities of time measure and rhythm as well as the essential form of color which can be placed in the square to interplay with number forms. My daughter Anna said, "You make different things the same."[38]

Making different things the same is central to Jensen's thought. The category of "sameness" is arrived at primarily through magical connections or sympathies which unite different things and allow them to correspond and coalesce with each other. In Jensen's introduction to an exhibition at The Pace Gallery, New York, in 1973, he wrote that his work was done "by conceptions being placed side by side in patterns, and of (magic) things that influence one another and not by acts of mechanical causations" — the word "magic" inserted in Jensen's handwriting in the typewritten introduction. Jensen cites Joseph Needham's Science and Civilization in China as an important influence on his work in this regard. In a 1961 catalogue introduction, he quotes from a section of Needham's book entitled Correlative Thinking and Its Significance.

Magic issues by a thousand fissures from the mystical life, from which it draws its strength, in order to mingle with the life of the laity and serve them. It tends to the concrete, while religion tends to the abstract. Magic represents coordinative thinking or associative thinking. Magic has a characteristic thought-form of its own as it is placed side by side in pattern, and things influence one another not by act of mechanical causation, but by a kind of inductance.[39]

The correlative value of magical thought led Jensen to perceive the magical properties of both color and number, resulting in such early paintings as *Magic Colors* (1959), *Magic 26* (1960), and *Odd and Even Magic* (1960).

To see similarities between different things is to perceive the original kinship of all things, a perception whose most suitable spatial manifestation is the square. Jensen's life-long absorption with the ideal properties of the square and the rectangle, and his use of the mathematical extensions of square numbers themselves, are a mode of pictorial unification which parallels mythic unification. By using the square, Jensen allows every formal element — color, number, shape, and edge — to be balanced by its equivalent. The basic and natural tendency of the human mind to do this, to split things into contrasts and complementaries, is thought to have been almost universal at some point in human development.[40] In primitive societies this is called moiety organization, and is a basic schematization of life and thought even to the present day.

The square is an ideal, simple vehicle for those complex combinations of opposites that can "make different things the same." In the mythical concept of space, likewise, dissimilar elements are assimilated in such a way as to make them mutually comparable and in some way similar.[41] Thus, the formal structure of a painting like *Unity in the Square, Per I and Per II* (1967) is analogous to the structuring of mythical space. In Egypt, for example, the pyramid builders used a fixed, rigid geometric form to suggest the negation of temporality. All reality and all life were seen as confined within this form, which became a symbol for immortality and infinity. Here, the interrelationship between spatial and temporal dimensions is clear.[42] Similarly, in ancient Chinese thought, all things and events can be aligned according to the spatial configuration of the cardinal points, which form a square. Each occurrence has a color, a sign of the zodiac, and a season, so that through a series of complex spatial and temporal interrelationships, a universal world-view is represented.[43] The Roman *templum* (which is derived from the verb *contemplare*) was the place from which the Roman augur observed the heavens; its square configuration conforms to the four cardinal points, as did the Christian spatial idea embodied in the construction of churches. The balanced, quadripartite, spatial organization of Jensen's paintings suggests not only an intuitive understanding of the meaning of spatial configurations in other cultures, but a parallel motivation for their use.[44]

For Jensen, the square or rectangle is an ideal vehicle for reciprocal spatial relationships in which all elements can be assimilated into a single structure, resulting in a unity which is both practical and theoretical, visual and structural.

There is, in his work, no differentiation between the whole and its parts; the two are inseparable. Each square, or series of squares, is part of another, larger series and at the same time contains within it yet another series. The pictorial function of such micro- and macrocosms is the same as an anthropomorphic function. The people of early civilizations, by anthropomorphizing astrological bodies, saw their lives and destinies reflected in the heavens just as they saw in human activities a reflection of the gods. People "humanized the heavens and spiritualized the earth and so melted sky and earth together in an inextricable unity. By opposing culture to nature in this way, man allotted to himself [sic] a special spiritual destiny."[45] The extraordinarily magical, spiritual quality of Jensen's work — which has led people to refer to it as mystical — is in part due to the effect of this *pars pro toto* principle, another essential aspect of mythic thought, in which

> *the part is immediately the whole and functions as such . . .*
> *The part, in mythical terms, is the same thing as the*
> *whole, because it is a real vehicle of efficacy — because*
> *everything which it incurs or does is incurred or done*
> *by the whole at the same time.*[46]

Jensen's work is rooted in both mythical and scientific views of the world, which are each dominated by the same kinds of relation: "unity and multiplicity, coexistence, contiguity, and succession."[47] The paintings are important not only because of their sheer optical beauty, but because they express and combine ways of thinking that are not indigenous to aesthetic modes. The work, in Jensen's own words,

> *is a structure complex and not easy to unravel, nor can*
> *the truth inherent in its build-up easily be read. My*
> *work is too integral in its make-up to tear it apart and*
> *thus to analyze the fragments of truth gleaned from its*
> *fractured remnants. My art represents a wholeness, a*
> *free time and space structure, a color and form*
> *realization equal to a vision beyond verbal*
> *explanation.*[48]

Time
In Jensen's work time and space are inextricably linked. The configuration of the panels, especially the large murals, allows forms to relate both forwards and backwards in continuous series, a relationship which suggests an infinite temporal dimension. The titles of many of the very large murals — *Beat of Time* (1966), *Square Beginning — Cyclic Ending* (1960), or *Spectral Timing* (1975) — indicate Jensen's view of time as continuous, as, in Cassirer's words, "a never ending sequence of becoming."[49] In the mythical concept of time,

all things have the same dimension or duration. This temporal sense, most highly developed among the ancient Greeks, intrigued Goethe as well. It is a speculative view of time which is closely related to an artistic view; it is not measured according to events, but seen as pure form.[50]

A principal means by which time is perceived, especially by the early civilizations that are Jensen's primary sources, is light. In many cultures, time is linked with the general worship of light, and in all civilizations its measurement originates in noting the rising and setting of the sun, the appearance and disappearance of light. For Jensen, solar phases, the spectral waves and energies of light have a temporal dimension. *The Sun Rises Twice* (1973) is an enormous canvas on which seasons are diagrammed, cardinal points located, days, months, and years delineated. The diagrammatic, calendrical form of this painting in particular relates it to the study of time, which in all cultures is manifested symbolically, formally, and conceptually in the calendar. *Spectral Timing* (1975), which is the largest mural Jensen has executed to date, relates to an earlier, single-panel painting of 1962, *East Sun. Perpetual Motion.* Both use circular forms. In the earlier work, movement is diagrammed by four arrows pointing counter-clockwise. Polarities, light and dark, positive and negative, and prismatic colors are employed. This work transforms the sense of motion into a sense of time, with overlapping circular configurations representing motion as change. The images move across the huge canvas, their position altered through spectral and prismatic permutations; solar and lunar relationships are diagrammed, and time is counted in minutes.

The Mayan calendar is a complex conceptual system, which offers in its ritualistic configuration a prototype worthy of Jensen's most systematic researches. The Mayan astronomers were among the most outstanding of all time. Without the aid of instruments, they were able to measure the rhythmic movements of the astral bodies with astonishing exactitude; like Jensen, they conceived of the passage of time as a flow rather than a progression.[51] Consequently, much of their culture was devoted to the research, analysis, and recording of temporal events. Their vigesimal calendar was based on a ritual year of eighteen months of twenty days apiece. A *Katun* was twenty years. The number twenty was the base figure used in the building of their pyramids as well. The Mayan calendar paintings which range throughout Jensen's career are based on extraordinarily intricate and numerical divisions, corresponding to the Mayan model of a divine governing order. In Mayan culture, the mythic correspondence of dissimilar things which stand for each other is paramount.

A sacrificial clay figure, for example, is at once a receptacle and the main element in a hieroglyph which, in combination with certain magical numbers, might represent the ritual three hundred sixty-day year. The hieroglyph would, at the same time, stand for such other elements as air, wind, life, and spirit.[52] The endless interconnections between number, symbol, and image in Mayan art are similar to the interconnections between the same elements in Jensen's work.

Time is also perceived in terms of measure, of periodicity, of rhythmic intervals, beats, or notes. When a measure is exact and unchanging, time is eternal or cyclical, rather than progressive. The religions of both Egypt and China, studied extensively by Jensen, are based on the idea of the existence of an immutable and universal measure, from which all human activity can be derived, regulated, and understood. By means of the calendar, which schematizes time according to the rising and setting of sun and moon and the evolution of the seasons, even an ethical dimension can be assumed, for in early civilizations activities, rituals, and behavior were regulated by the calendar. Therefore,

> a relation between the universal temporal order, which governs all events, and the external order of justice, which likewise presides over all happenings — the same link between the astronomical and ethical cosmos — is found in nearly all the great religions.[53]

Time is measured by the phenomena of light, change and rhythm, and these in turn regulate ethical and normative behavior. In Jensen's work, periodicity is manifested pictorially, but the sweeping grandeur and the authority of such paintings as *Spectral Timing* express the clarity of true spiritual conviction. The "religious" quality of Jensen's work is not altogether unintentional; the titles of many of his paintings throughout his career allude to such concerns: *Eternity* (1959), *Divine Analogy* (1963), *A Divine Mission* (1976).

Time is measured not only by light and by periodicity, but by births and deaths, that is, by generations. The regenerative sense of time is specifically the subject of Jensen's *The Family Portrait* (1975). Since the birth of his daughter Anna in 1965 and his son Peter in 1970, their presence has been celebrated in his work both emotionally and philosophically. In this portrait, Jensen, his wife and their children become part of the same world-view of universal relationships and correspondences that make up the underlying theoretical and pictorial structure of all his work. Here, equivalences are made between Chinese syllables *(chien, chen, k'un* and *sun)* and their respective multiple meanings, the colors of the spectrum, including

black and white, protons and neutrons, and the stick symbols of the *I Ching.* Important here is Jensen's belief that although "all cultures are linked, Egypt and the Middle East are not the cradle of civilization — rather, China is." *The Family Portrait,* like other paintings, suggests many relationships to ancient Chinese culture and thought, in which human beings were conceived of as part of a vast continuum which included all natural and spiritual things. According to Cassirer, a feature of the Oriental ancestor cult is the binding of individuals to their ancestors by the process of generation, which is a continuation of the individual through one's children and grandchildren. This idea of continuity is paralleled on the tribal and thus on the national level, every aspect of this possessing mythic implications; ultimately, the expansion of this kind of social consciousness is related to the character of the gods.[54] In Jensen's personal symbology, "half," was the original number, standing for man. It was then joined by a second "half," woman. The male/female polarity found in so much of Jensen's thinking equates white with male, father, day, and black with female, mother, night. Just as the colors are the children of black and white, so in *The Family Portrait* Jensen's wife and daughter are represented by black squares, the artist and his son by white ones and all elements in the painting are both divisible by two (female), and composed of odd numbers (male). Each square consists of thirteen rows across. The painting itself is a four-part work divided into two panels, with two blocks of squares on each side, the whole configuration consisting of a square with four basic units of measure.

The number four is significant in China, as in many other cultures; the complexity of the Chinese system is reflected in Jensen's thought:

> In the Chinese system, a particular season, color, element, animal species, organ of the human body, etc. corresponds to each one of the principal directions, west, south, east, and north, so that ultimately, by virtue of this relation, the entire diversity of existence is in some way distributed, and, as it were, fixated and established in a particular intuitive sphere.[55]

Similarly, in the *Book of the Tao* and the writings of Confucius, "ethics becomes the doctrine of man's four immutable attributes which are the same as those of the heavens, which are as eternal and unchanging as the heavens themselves."[56] Jensen's family portrait thus incorporates macrocosm and microcosm, Yin and Yang, color theory, time, space, heaven and earth, into a single plane of being, a single unified visual system that suggests its own infinite reproduction; at the same time, it is a touchingly individualized, personal cosmology.

Number

While mythical concepts of space and time have parallel manifestations in Jensen's work, a third factor, that of number, is one of the most striking formal features of his painting. It completes the triad of factors which coalesce to form an entire system of experience. In this respect Jensen's work illustrates the central character of mythical thinking; "the representation of order in coexistence, of order in succession, and of a stable, numerical, quantitative order of all empirical contents form the foundation for an ultimate synthesis of all these contents into a lawful or causal world order."[57]

Number has a universal symbolic significance. The cardinal numbers symbolize the immediate experiential relationships between one, two, or more individuals, that is, the idea of the self in relation to others. It is no surprise that Jensen is a student of Pythagorean theory. Pythagoras (582-500 B.C.) and his followers made the first scientific discoveries of number, and yet their views were dominated by a magical-mythical view of numerical significance, involving geometry as well as arithmetic.[58] According to the Pythagoreans, number is universal and relational, subject to that law by which dissimilar elements are rendered the same and brought into harmony with each other. Number is an all-embracing, universal element, extending over the entire field of being. "'Number,' says one of the Pythagorean texts, 'is the guide and master of human thought. Without its power everything would remain obscure and confused' . . . In number, and number alone, we find an intelligible universe."[59]

Number in the Pythagorean system is linked to the sensuous world but subject to the laws of harmony and relationship. The use of number also implies the acquisition of knowledge beyond the capacity of sensuous intuition, number and truth being essentially related and known only one through the other. Number is also an ideal vehicle for thought, "since it seeks to apprehend the content of being as an ordered content."[60]

Although all of Jensen's works are in some way based on numerical systems, many of the works which incorporate number as the primary formal element are abstract systems of measurement. *190 Columns of a Temple* (1962) is a fragile, exquisitely luminous graphic rendering of the measurement of architectural columns, structured in the numerically and visually columnar form that is the convention for the calculations of addition and subtraction. The repetition of the figures and the hand-made, wobbly lines and numbers give the work a vulnerability not associated with mathematical tables in general.

One difference between poetry and utility in Jensen's diagrammatic systems has not so much to do with their actual function as a diagram — since Jensen's diagrams *do* "work" — as with the special quality of his handwriting, most evident in the drawings but also in the thick, tremulous, hand-made quality of his painted marks. The drawings contain an oil-soaked "halo" or aura surrounding the painted areas. The halo caused by the oil soaking through the paper serves a similar function as do the blots and meanderings of Jensen's drawn lines when they occur; it highlights the intimacy of the work. It also separates and emphasizes elements of the drawing in the same way as the leading on medieval stained-glass windows makes the colors of the glass appear more luminous, or the mortar binding mosaic tiles visually isolates the individual elements of the pattern. By virtue of this separation, the logical numerical aspects of Jensen's work also become clarified, as each numbered section is visually allotted its own distinct space and character.

Number has a sacred dimension both in its simple components and in its aggregate nature, insofar as the part is found in the whole, the small in the large, and vice-versa. The cosmic character of any given number, then, permeates the entire configuration in which it is used. *The Tetractys,* a mural-sized painting of 1964, does not use numbers as such, but employs a background of pyramids of ten dots within a square, black on white and white on black, arranged on a rectangular grid. On this grid are green and orange squares in three different configurations, a rectangle, a pyramid, and a square spiral. In this painting, number is both concrete — i.e., the result of counting marks — and abstract at the same time, since the painting suggests the ten-part infinite additions, multiplications, and combinations possible through conceptualization rather than counting. The mysterious character of Jensen's paintings has to do, in part, with the mystery of number itself, since number is the ideal vehicle not only for spiritual expression, but for magical concepts as well. The magic of number, in myth as in Jensen's work,

> *proves itself to be the bond which joins the diverse powers of consciousness into a mesh, which gathers the spheres of sensation, intuition, and feeling into a unity. Number thus fulfills the function which the Pythagoreans impute to harmony. It is "a Unity of many mixed elements;" it acts as the magic tie which not so much links things together as brings them into harmony within the soul.* [61]

Number thus has power, not only the magical power to relate things to each other, but the transcedent power to impart its essence to all things. When Jensen examines any given form or situation, such as the images on the Parthenon frieze, a column, a Mayan temple, an Egyptian pyramid, a rainbow, or the writings of a 19th century physicist, and sees the numerical relations inherent in it, he is considering number in its mythical form, that is, as a primary and fundamental form of relation. In Jensen's work, as in mythical thinking at large,

> *everything which knowledge, which science, considers under the name of "nature" is built up out of purely numerical elements and determinations which serve as the actual instruments by which to recast all merely accidental existence into the form of thought, law, and necessity . . . While in scientific thinking number appears as the great instrument of explanation, in mythical thinking it appears as a vehicle of religious signification.* [62]

Jensen's latest series of drawings, on large, smooth cardboard sheets, is an infinite numerical series. The two drawings of the series in this exhibition *(The Sum of the Earthly Numbers is Thirty* and *The Sum of the Heavenly Numbers is Twenty-five)* combine numerical series and color series, using black numbers on white and their opposites, and colored numbers on different colored squares so that the series can be read by following both the figures and the ground. The color and number systems are cross-referenced. We have, in these drawings, a perfect example of the kind of simple visual patterning which can result from the most complex numerical structures.

III

Thus far, in his use of space, time and number, Jensen's work and attitudes perfectly parallel, and can be elucidated by, Cassirer's analysis of mythical thinking. Jensen's work clearly goes beyond the primitivism often attributed to it, even insofar as the term implies purity, integrity, unselfconsciousness, and even a kind of aesthetic heroism. His work deals with the very structure of mythical thinking, which has informed all of the great religions, civilizations, and monuments of the world. This structure remains the foundation of contemporary life.

However, an aspect of Jensen's work as integral and important to it as myth is has been considered — in the history of art and in most present-day art criticism as well — outside the scope of art, perhaps anathema to it. This is Jensen's constant fascination with the physical sciences, especially with the discoveries of such 19th century pioneers as Oersted, Maxwell, Faraday, Minkowski, and Lorenz. These men were interested in the properties and effects of electricity both as current and as field, that is, in the properties of electricity in motion. Their discoveries,

especially those of Faraday, have been symbolically incorporated into Jensen's paintings over the years, and are as integral to the work as color theory, number, proportion, and opposition.

Even though it would seem that the arts and the sciences have always been polarized to some extent, a salient factor in thinking about contemporary art is a new attitude about the potential relationship of art and science. For most contemporary artists interested in science, it is the scientific form, or technology itself rather than theory, which is of interest. Jensen, however, gives pictorial reality to scientific postulates and discoveries, incorporating scientific theory in his work to such an extent that form and theory are inseparable. In the past three years, Jensen has returned specifically to a study of electromagnetism and a re-examination of Goethe's color theory. These researches have culminated in the 1977 series of drawings and paintings which, appropriately, utilize number as their major formal component.

The works between 1957 and 1977 most directly addressed to scientific issues, especially the 1975 works based on the optics of physical or solar energy, do not form a stylistic group. For instance, the extraordinary *Correspondence in Function of Magnet and Prism* (1961), composed of squares divided into opposing black and white triangles with a thin, shimmering border of red and blue, contains arrows and letters corresponding to the four cardinal points. It relates to other predominantly black and white works, like *Aurora, Per VI, Motion in Coloristic Orbits* (1961) which uses a similar bordering device in circular, rather than triangular, configurations. A 1957 drawing, *A Prism's Light and Dark Spectral Color Action*, whose triangles and parallelograms are also bordered, almost imperceptibly, in red and blue, consists of a vertical mirror image; *The Acroatic Rectangle, Per Three* (1967), a striking black and white vertical painting, also embodies the same straightforward oppositions, creating a shifting optical space in which two planes of activity seem to reverse themselves.

Two 1975 works, *Physical Optics* and *Negative Optic Electric Force, Positive Optic Electric Force*, do not contain numbers or formulae, but seem, in their circular spectral banding and prismatic color range, related to works based on temporal concerns, such as *East Sun, Perpetual Motion* (1962) or the enormous mural *Spectral Timing* (1975). In *Mr. Faraday's Diagram* (1975), however, this banding becomes a visual analogy for Faraday's description of the reality of matter dissolving into lines of force.[63] The bands in this painting emanate from alternating black and white circular forms.

Solar Energy Optics (1975) bears a close formal resemblance to *A Divine Mission* (1976), a truly climactic work which unites all aspects of Jensen's thought into a single, monumental painting. In both works, visual, verbal, chromatic, and numerical systems are combined. Both are three-panel paintings of considerable size, whose basic forms are the symbols for proton and electron, plus and minus signs, black and white and colored diamonds and squares, *I Ching* symbols and words. Jensen has inscribed on *Solar Energy Optics: Magnetic forces from the Sun's four separate magnetic fields oscillates. In that way an electric field registers Solar Energy.*

The formal aspect of these paintings parallel in many other ways the ideas of the scientific geniuses upon which the paintings are based. For instance, Minkowski's great contribution was to use the concept of grouping to translate the theory of relativity into mathematical form, achieving a union of space and time.[64] Maxwell was able to determine the relationship between optical phenomena and electrical behavior.[65] In defining light as an electrodynamic process, Maxwell facilitated the step from the physics of matter to pure field physics, in which the "field" is postulated as an aggregate of physical relations, each part defined by and inseparable from the whole.[66] The result of Maxwell's discoveries provides significant counterpart in the realm of science to Jensen's pictorial images. It is in Jensen's amalgamation of the aesthetic and the scientific that his contribution rests.

Cassirer, in the last volume of his great trilogy *The Philosophy of Symbolic Forms*, sums up the process of symbolic formation as having three stages — representation, expression, and pure meaning. The formulation of art, like that of language and myth in general, stems from expression; Cassirer believes that art remains in this sphere of primary or "primitive" experience.[67] Science, however, belongs to the world of pure meaning, and it is here, he says, that science's concept of truth and reality definitively breaks from representation and enters the arena of abstract thought. With Einstein, says Cassirer,

> the schematism of images has given way to the symbolism of principles . . . The tendency toward unification has triumphed over the tendency toward representation . . . Ordering has thus become the actual and absolute foundation of physics; the world itself is represented no longer as a coexistence of thing unities but an order of "events." [68]

Thus, in science, intuitive space and time are replaced by an abstract, four-dimensional continuum. Color, for instance, is no longer a vibration of the ether, but colors

appear in modern science "only as mathematical, functional processes of a periodic character."[69] Thus, when Jensen says, "I have gone from phenomenal color to mental color" in describing *A Quadrilateral Oriented Vision,* or when he says that he had been painting phenomena but now wanted to paint "a mental image," he is expressing in visual terms a leap of understanding and method analogous to that found in the essential transition from early to modern science. The scope of a painting like *A Divine Mission* can perhaps be best understood not by reference to any stylistic development in the history of art, but by analogy to a scientific achievement of this kind.

The gap between art and science is persistent and well known, and attempts have been made sporadically to analyze and resolve the dichotomy. One historian, George Kubler, has discussed the possible relationship between the two areas of investigation when he proposes that a system of metaphors drawn from physical science would be better suited to describing art than the biological metaphors presently in use, i.e., artistic style seen as a sequence of life-stages or cycles, implying progressive growth. In art, Kubler says,

> *we are dealing with the transmission of some kind of energy; with impulses, generating centers, and relay points; with increments and losses in transit; with resistences and transformers in the circuit. In short, the language of electrodynamics might have suited us better than the language of botany; and Michael Faraday might have been a better mentor than Linnaeus for the study of material culture.* [70]

Jensen doubtlessly would agree. Jensen's work, in its singular lack of progressive stylistic evolution, not only is perfectly adaptable to Kubler's description of what art is and does, but it also suggests, in its pictorial form, a similar metaphor.

Kubler, in his discussion of art and science, notes that the habit of separating the two fields "goes back to the ancient division between liberal and mechanical arts,"[71] which has had the effect of blinding us to the common aspects of the two in the same historical perspective. Artists of the Renaissance were more than conversant with early experimental science, and the writings and drawings of Leonardo are testimony to this interconnection. Similarly, Goethe, at the end of the 18th century, was at once a scientist, a poet, a philosopher, and a theoretician, and refused to limit his imagination to any single area. Kubler notes that artists and scientists are more like one another than they are like anything else, because "both art and science deal with needs satisfied by the mind and the hands in the manufacture of things."[72] However, he

surmises that "although a common gradient connects use and beauty, the two are irreducibly different: no tool can be fully explained as a work of art, nor vice versa."[73]

According to Thomas Kuhn's theory (in *The Structure of Scientific Revolution,* 1970) the extraordinary gap between art and science, once bridged by Leonardo, deepened only when painting and sculpture "unequivocally renounced representation as their goal and began to learn again from primitive models."[74] Kuhn refutes the idea of linear progress in science, substituting instead the idea of the paradigm. Paradigms are achievements which are unprecedented, open-ended enough to be unable to explain all the facts with which they can be confronted, and which attract a group of followers away from competing modes of activity. A paradigm is a model composed of symbolic generalizations, shared values, shared commitments to beliefs.[75] Examples of general paradigms in history include Ptolemaic astronomy as well as 19th century "wave optics," although most paradigms are more specialized. Kuhn cites Maxwell's mathematization of the electromagnetic field. One might also cite Faraday's concept of the particulate nature or "atomicity" of electrical charges.

The idea of progress is not, in Kuhn's thinking, as valid as the attempt to establish the historical integrity of an idea in its own time, so that, in Kuhn's view, Maxwell's discoveries were as important as those of Einstein. It is for this reason that the schism between art and science deepened irrevocably at the moment when representation ceased to be an aesthetic goal. Without representation, linear progress toward any goal became impossible. No other goal in the making of art had been so pervasive nor endured so long. Some artists and critics have attempted, in recent decades, to postulate new, non-representational goals;[76] some have simply acknowledged that to forfeit goals is to forfeit the idea of progress in its entirety. Many critics complain that the art of the 1970s is heterogeneous, and find the simultaneity of styles and the absence of aesthetic "leadership" baffling and detrimental to artistic progress. Others attack works of art as invalid or simply bad when there is no clear stylistic art historical precedent from which the work has "evolved." It is therefore not surprising that Alfred Jensen, at the age of seventy-four, is having his first major museum exhibition in America. Jensen has been described as "an artist's artist," someone who, throughout his career, has been admired and understood by other artists, each interested in a different aspect of his life and work. Jensen is uniquely an artist of the present time; his non-hierarchic, intensive method of

research and his lifelong concern with extra-art ideas and knowledge only now are becoming part of general public consciousness.

What is unique in Jensen's work is the amalgamation and unification of heterogeneous systems, values, ideas, symbols, and modes of thought. In science, the physics which Jensen has studied for a lifetime has increasingly sought, and found, more universal symbols for the physical world. The great cultures which Jensen has researched are those to which we still turn for literary, philosophical, and artistic inspiration. These are the ancient civilizations — Babylonian, Mayan, Egyptian, Greek, Chinese — in which the seeds of all knowledge were sown. Jensen has combined sensuous expression, intuitive knowledge, mythic vision, and scientific reality in a ceaseless attempt to order the universe as he perceives it. In the world, says Cassirer, "there is a conceptual depth as well as a purely visual depth. The first is discovered by science; the second is revealed in art."[77] It is the heroic impulse of Alfred Jensen to seek to provide us with both.

I first became familiar with Alfred Jensen's work in the early 1960s; its apparent visual simplicity and its complex, abstruse systematization of numbers, symbols, and colors was unlike any work of that period I had seen.

In 1969, while organizing an exhibition devoted to the issue of color, I spent many hours looking at and thinking about Jensen's work. The painting and the drawings I chose for that exhibition *(The Structure of Color,* Whitney Museum of American Art, New York City, 1970) made a lasting impression; it was at this time that Linda Cathcart and I, working together, first discussed the future possibility of this retrospective.

I would like to thank Linda Cathcart for having shared with me the opportunity of selecting, from Alfred Jensen's studio, the paintings for the exhibition, thus culminating our initial intention of an earlier time. I am also grateful for her assistance in obtaining and sharing with me the records of Jensen's life and work which formed the factual basis for this essay.

Thanks also to Timothy Yohn for his discussion, advice, and editing of this essay; to Allan Schwartzman for correcting and typing the manuscript; to the staff and friends of The New Museum for their patience while I was absent, writing; and to Alfred and Regina Jensen, for their warmth, hospitality, and assistance.

Footnotes

1. Ernst Cassirer, *An Essay on Man* (New Haven and London, 1944), p. 221. [I have taken the liberty of slightly altering the epigraph so as to conform to the style suggested by *Language Guidelines* (McGraw-Hill Book Company, New York, 1975).]

2. All quotations from Alfred Jensen, unless otherwise noted, were taken from Linda L. Cathcart and Marcia Tucker, Interview with Alfred Jensen (Glen Ridge, New Jersey, 30-31 March 1977), unpublished.

3. Allan Kaprow, "The World View of Alfred Jensen," *Art News,* vol. 62, no. 7 (December 1963), p. 30.

4. See John Loring, "Checkers with the Right Man," *Arts Magazine,* vol. 47, no. 5 (March 1973), pp. 60-62, Kaprow, "World View;" and brief reviews appearing in various art periodicals between 1958 and 1973.

5. Loring, "Checkers," [from a lecture Jensen gave at Columbia University in 1972.], p. 62.

6. Leila Hadley Musham, "Alfred Jensen: Metaphysical and Primitive" (New York, 1975), unpublished, p. 20.

7. Ibid. p. 21.

8. Ibid. p. 17

9. Ibid. p. 19.

10. Emily Wasserman, "Tantra," *Artforum,* vol. VIII, No. 5, (January 1970), pp. 46-50. [Jensen, however, is strongly opposed to the analogy between Tantric Art and his own, "Because I feel that Tantric-Indian Art Diagrams are a bad imitation of Chinese ancient art forms and because the Diagrams are used for ritualistic purposes, made to serve the purpose of the Buddist Monk's greed." In a letter to the author 8 August 1977, Jensen adds: "All my own effort has been to liberate our concepts to use art as a freeing agent, to equalize life amongst men and women. To get away from conventional rules of preaching inequalities and to avoid submitting to the edicts of a priesthood and its Temple's Rule."]

11. Bruce Boice, "Problems from Early Kupka," *Artforum,* vol. XIV, no. 5, (January 1976), pp. 32-39.

12. Paintings like *Reciprocal Relation, Per 1 and Per 2,* 1969, and *Beat of Time,* 1966, in which adjacent bands of color begin at the outer edges of the square and become progressively smaller to convene at the center, have a closer affinity to Stella's work than to Albers'. Albers used a simpler square configuration to focus on color relationships alone. Stella also used a color system as a point of departure; his 1962 two-panel painting, *Jasper's Dilemma,* and Jensen's *Beat of Time* have a similar formal organization.

13. Lucy Lippard, *From the Center* (New York, 1976), p. 187.

14. See Jeff Perrone, "Approaching the Decorative," *Artforum,* vol. XI, no. 4 (December 1976), pp. 26-30.

15. Cassirer, *Essay on Man,* p. 209.

16. Musham, p. 17.

17. Ibid., p. 14.

18. Donald Judd, "Al Jensen," *Arts Magazine,* vol. 37, no. 7 (April 1963), p. 52. [Judd prefaces his remarks by saying: "Now and then a chance occurs for a narrow, subjective, categorical statement: Jensen is great. He is one of the best painters in the United States."]

19. Musham, p. 11.

20. Goethe, quoted in Cassirer, *The Phenomenology of Knowledge* in *The Philosophy of Symbolic Forms,* vol. III (New Haven, 1957), p. 11.

21. Musham, pp. 10-11.

22. Ibid., p. 8.

23. Alfred Jensen, "The Promise," *Hasty Papers: A One-Shot Review* (1960), p. 49.

24. *Alfred Jensen,* Stedelijk Museum exhibition catalogue (Amsterdam, 1964), n.p.

25. Cassirer, *Mythical Thought* in *The Philosophy of Symbolic Forms,* vol. II (New Haven, 1955), p. 96.

26. Ibid., p. 96.

27. Troels-Lund, *Himmelsbild und Weltanschauung im Wandel der Zeiten* (3rd ed. Leipzig, 1908), p. 5. [quoted in Cassirer, *Mythical Thought,* p. 97].

28. Cassirer, *Mythical Thought,* p. 36.

29. Goethe, quoted in Cassirer, *Phenomenology,* p. 394.

30. Cassirer, *Mythical Thought,* p. 16.

31. Goethe, quoted in Cassirer, *Mythical Thought,* p. 16.

32. Cassirer, *Mythical Thought,* p. 80.

33. Ibid., p. 138.

34. Ibid., p. 89.

35. Cassirer, *Essay on Man,* p. 210.

36. Ernest Becker, *Escape from Evil* (New York, 1975), p. 78.

37. Cassirer, *Mythical Thought,* p. 25.

38. Alfred Jensen, "Explanations for a Friend and Artist," *Alfred Jensen: The Aperspective Structure of a Square* (Cordier & Ekstrom, Inc., New York, 1970), n.p. Text based on a letter from Jensen to Allan Kaprow, 24 September 1969. Reprinted as "Jensen Mikro Makro," in *documenta 5: Internationale Ausstellung* (Museum Fridericianum, Kassel, 1972) and *Alfred Jensen* (Kestner-Gesellschaft, Hanover, 1973).

39. Musham, p. 30.

40. Becker, *Escape,* p. 10.

41. Cassirer, *Mythical Thought,* p. 86.

42. Ibid., pp. 127-128.

43. Ibid., pp. 87-88.

44. Ibid., p. 102.

45. Becker, *Escape,* pp. 18-19.

46. Cassirer, *Mythical Thought,* p. 49.

47. Ibid., p. 60.

48. Jensen, "Explanations for a Friend and Artist," n.p.

49. Cassirer, *Mythical Thought,* p. 114.

50. Ibid., p. 136.

51. H.D. Disselhoff and S. Linne, *The Art of Ancient America* (New York, 1960), p. 105.

52. Ibid., p. 105.

53. Cassirer, *Mythical Thought,* p. 114.

54. Ibid., p. 176.

55. Ibid., p. 147.

56. Ibid., p. 80.

57. Cassirer, *Phenomenology,* pp. 282-283.

58. Cassirer, *Essay on Man,* p. 211.

59. Cassirer, *Phenomenology,* p. 349.

60. Cassirer, *Mythical Thought,* p. 151.

61. Ibid., p. 143.

62. Cassirer, *Phenomenology,* p. 466.

63. Ibid., pp. 353, 471.

64. Ibid., p. 437.

65. Ibid., p. 465.

66. Ibid., p. 449.

67. Ibid., p. 448.

68. Ibid., p. 467.

69. Ibid., p. 467.

70. George Kubler, *The Shape of Time* (New Haven, 1962), p. 9.

71. Ibid., p. 10.

72. Ibid., p. 10.

73. Ibid., p. 11.

74. Thomas S. Kuhn, *The Structure of Scientific Revolution* in 2nd ed. *International Encyclopedia of Unified Science,* vol. II, no. 2, (University of Chicago Press, Chicago, 1970), p. 161.

75. Ibid., pp. 10, 18.

76. Clement Greenberg, the leading critic of the 1960s, substituted the idea that painting progresses toward the elimination of conventions not intrinsic to it. Accordingly, the "goal" of modernist painting would be ultimate flatness, lack of optical illusion, and emphasis on the shape of the rectangular support. Thus painting from the Renaissance on is seen as the evolution of a teleological drama.

77. Cassirer, *Essay on Man,* p. 169.

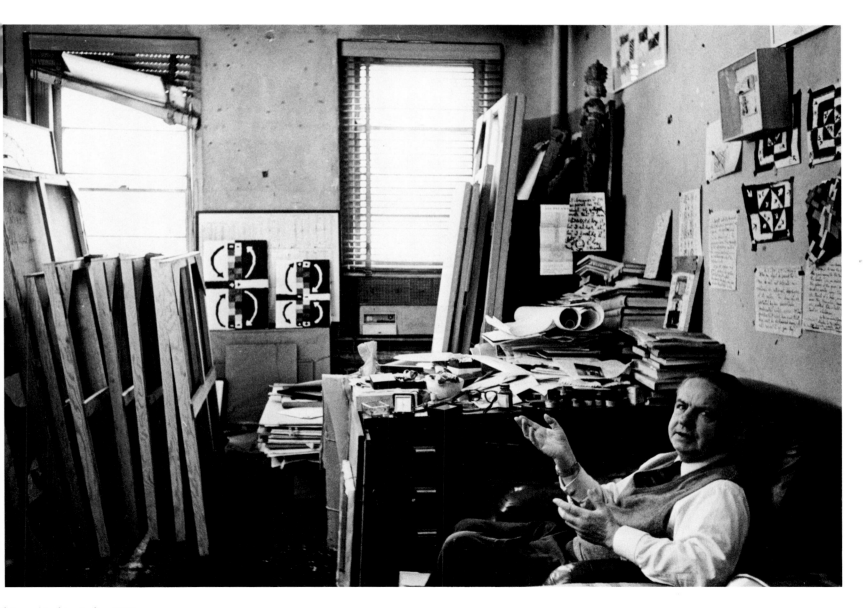

d Jensen in his studio, 1963

Catalogue of the Exhibition

All dimensions are given in inches with height preceding width.
"Per" refers to individual panels in multipart paintings.
All paintings are from the collection of Alfred Jensen.

1. *My Oneness, a Universe of Colours,* 1957
 oil on canvas, 26 x 22

2. *A Prism's Light and Dark Spectral Color Action,* 1957
 oil on paper, 35 x 27

3. *Galaxy I and Galaxy II,* 1958
 oil on canvas, 46 x 80

4. *Tattooed,* 1958
 oil on canvas, 36 x 25

5. *Zig Zag,* 1958
 oil on paper, 27 x 11

6. *Eternity,* 1959
 oil on canvas, 46 x 36

7. *A Glorious Circle, A Story of Cosmic
 Color Correlation,
 Per I, The North
 Per II, The East
 Per III, The South
 Per IV, The West,* 1959
 oil on canvas, 73 x 144

8. *Magic Colors,* 1959
 oil on canvas, 50 x 20

9. *Revolving Spheres,* 1959
 oil on canvas, 75 x 100

10. *Study Black and White,* 1959
 oil on paper, 26¾ x 21½

11. *Study in Color,* 1959
 oil on paper, 23½ x 22½

12. *Magic 26,* 1960
 oil on canvas, 54 x 30

13. *Square Beginning – Cyclic Ending,
 Per I, 80 Equivalent Squares of Value 5
 Per II, 48 Equivalent Squares of Value 5
 Per III, 24 Equivalent Squares of Value 5
 Per IV, 9 Equivalent Squares of Value 5
 Per V, 1 Square Area of Value 5,* 1960
 oil on canvas, 50 x 250

14. *Aurora, Per VI, Motion in Coloristic Orbits,* 1961
 oil on canvas, 68 x 54

15. *Correspondence in Function of Magnet and Prism,
 Per I, Circuit of White Electrons
 Per II, Circuit of Black Protons,* 1961
 oil on canvas, 50 x 84

16. *A Film Ringed the Earth,* 1961
 ink and collage on paper, 22 x 28

17. *Athena, Hephaistos Above; Aphrodite Below,
 Marduk,* 1962
 oil on canvas, 66 x 123

18. *Doric Order,* 1962
 oil on canvas, 54 x 54

19. *East Sun. Perpetual Motion,* 1962
 oil on canvas, 51 x 46

20. *The Light Color Notes,* 1962
 oil on canvas, 52 x 50

21. *Mayan Temple, Per IV, Teotihuacan,* 1962
 oil on canvas, 76 x 50

22. *Sixty Keys,* 1962
 oil on canvas, 52 x 50

23. *190 Columns of a Temple,* 1962
 ink on paper, 22 x 23

24. *Men and Horses,* 1963
 oil on canvas, 50 x 198

25. *Katun,* 1964
 oil on paper, 30 x 20

26. *The Tetractys,* 1964
 oil on canvas, 52 x 122

27. *Beat of Time,* 1966
 oil on canvas, 50 x 126

28. *Timaeus, Per I and Per II,* 1966
 oil on canvas, 60 x 100

29. *The Acroatic Rectangle, Per Three,* 1967
 oil on canvas, 62½ x 37

30. *The Acroatic Rectangle, Per Thirteen,* 1967
 oil on canvas, 74 x 59

31. *Unity in the Square, Per I and Per II,* 1967
 oil on canvas, 70 x 70

32. *Square 6 Growth,* 1968
 oil on canvas, 68 x 68

33. *Study for Mural at Albany Mall, New York,* 1968
 oil on canvas, 68¼ x 17¼

34. *Reciprocal Relation, Per 1 and Per 2,* 1969
 oil on canvas, 71 x 71

35. *Study of a Rectangle,* 1970
 oil on canvas, 66½ x 33¼

36. *The Chi Chu Diagram #1,* 1972
 oil on matboard, 30 x 20

37. *Mayan Katun*, 1973
 oil on matboard, 30 x 18

38. *The Sun Rises Twice*, 1973
 oil on canvas, 96 x 192

39. *The Earth's North-East-South*, 1974
 oil on canvas, 90 x 90

40. *Mayan Mat Patterns Number Structures*, 1974
 oil on canvas, 72 x 72

41. *Au Debut Du Printemps*, 1975
 oil on canvas, 74 x 148

42. *Electromagnetic Charge*, 1975
 oil on canvas, 86 x 51

43. *The Family Portrait*, 1975
 oil on canvas, 86 x 102

44. *The Marriage of Universal Darkness and Solar Light
 on Earth*, 1975
 oil on canvas, 70 x 70

45. *Mr. Faraday's Diagram*, 1975
 oil on canvas, 35 x 70

46. *Negative Optic Electric Force, Positive Optic Electric
 Force*, 1975
 oil on canvas, 70 x 140

47. *Physical Optics*, 1975
 oil on canvas, 86 x 153

48. *Solar Energy Optics*, 1975
 oil on canvas, 86 x 153

49. *Spectral Timing*, 1975
 oil on canvas, 51 x 255

50. *Taj Mahal, #8, #9, #10*, 1975
 oil on canvas, 70 x 105

51. *A Divine Mission*, 1976
 oil on canvas, 86 x 204

52. *A Place Value Component, Per I, Per II, Per III*, 1976
 oil on canvas,
 Per I, 15 x 48
 Per II, 13 x 48
 Per III, 16 x 20

53. *Progression: Vertical 5, Horizontal 15*, 1976
 oil on canvas, 51 x 86

54. *Diagram for a Prism Machine*, 1977
 oil on paper, 20 x 30

55. *The Sum of the Earthly Numbers is Thirty*, 1977
 oil on matboard, 30 x 40

56. *The Sum of the Heavenly Numbers is Twenty-five*, 1977
 oil on matboard, 30 x 40

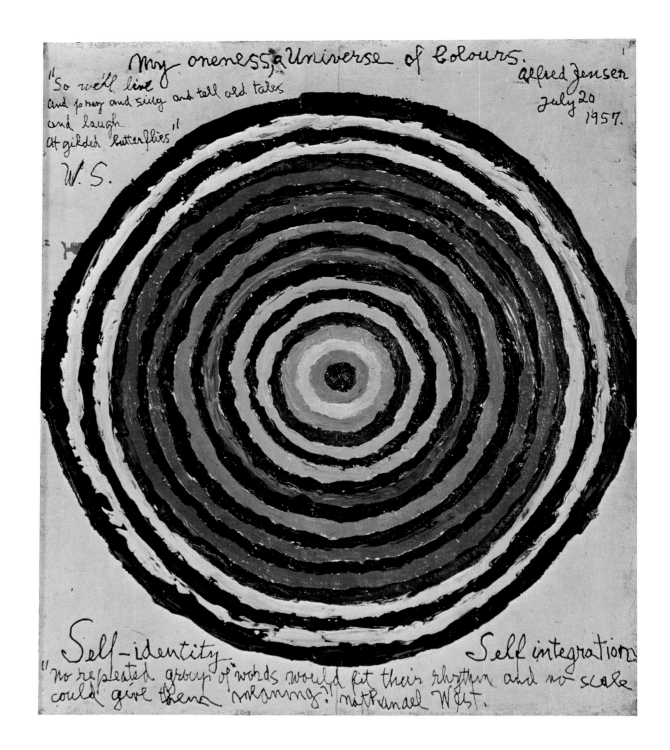

1. *My Oneness, a Universe of Colours,* 1957
 oil on canvas, 26 x 22

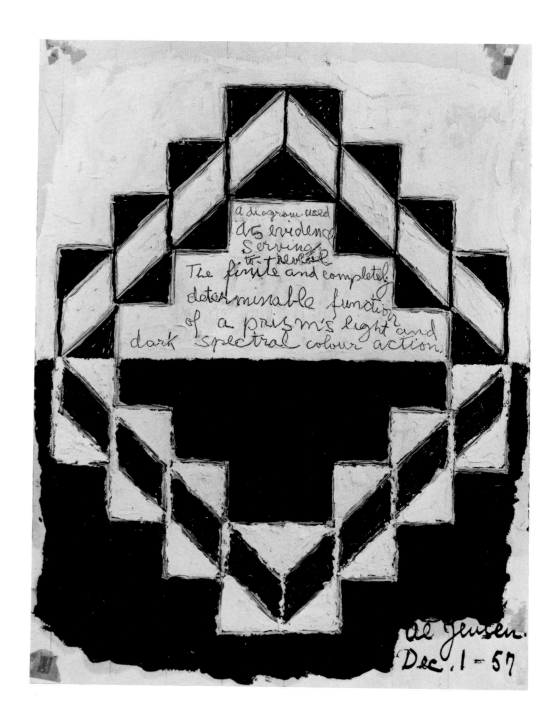

Prism's Light and Dark Spectral Color Action, 1957
on paper, 35 x 27

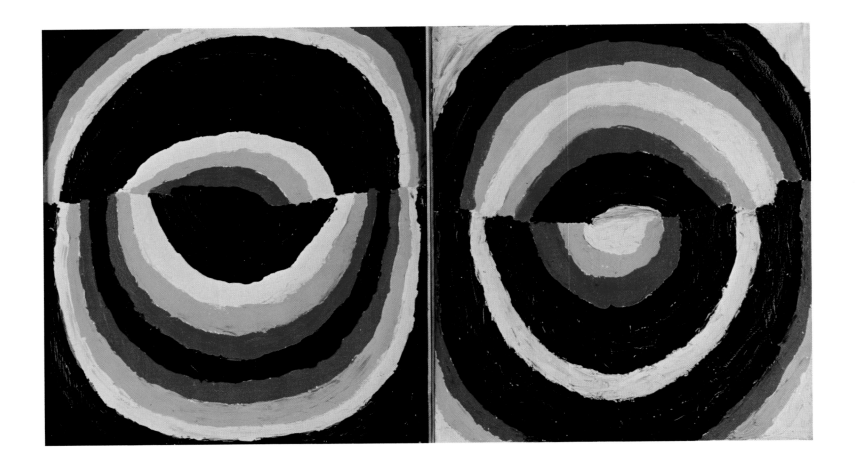

3. *Galaxy I and Galaxy II*, 1958
 oil on canvas, 46 x 80

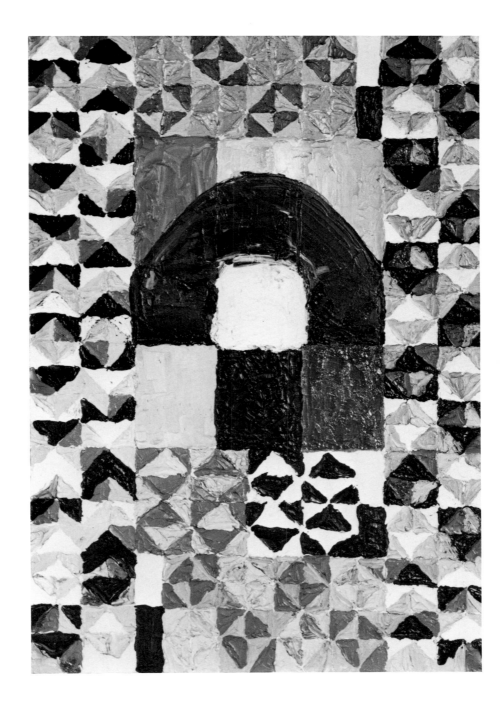

ttooed, 1958
on canvas, 36 x 25

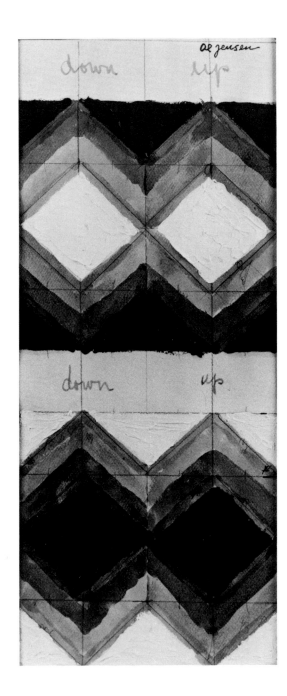

5. *Zig Zag,* 1958
 oil on paper, 27 x 11

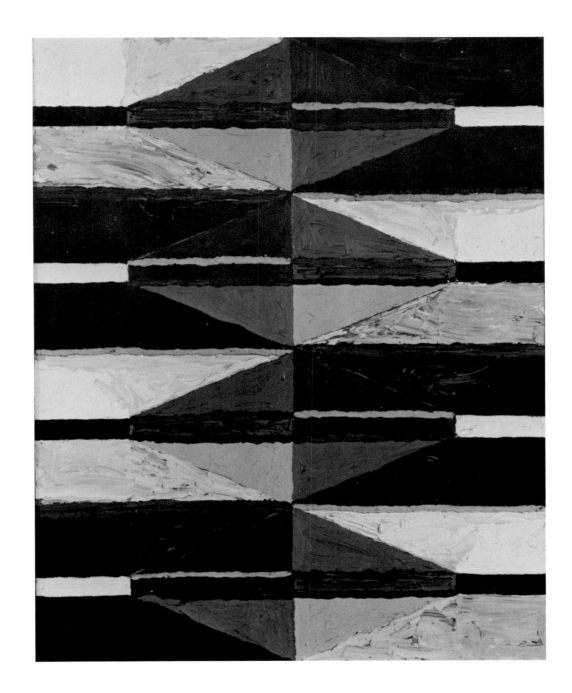

ernity, 1959
on canvas, 46 x 36

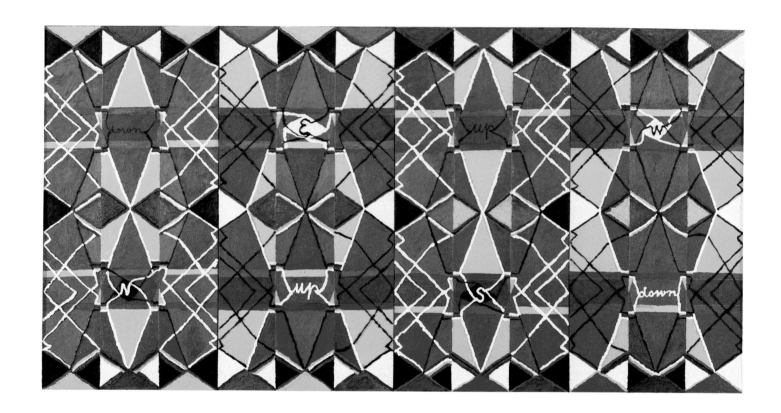

7. *A Glorious Circle, A Story of Cosmic*
 Color Correlation,
 Per I, The North
 Per II, The East
 Per III, The South
 Per IV, The West, 1959
 oil on canvas, 73 x 144

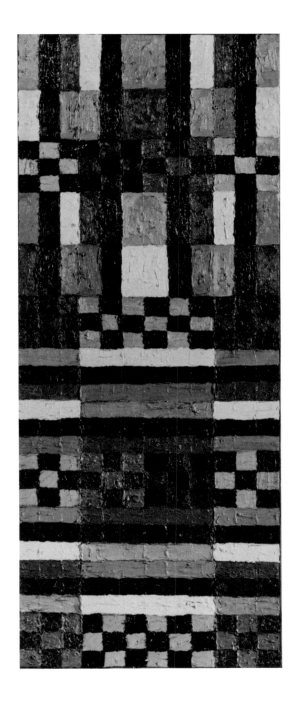

...agic Colors, 1959
...on canvas, 50 x 20

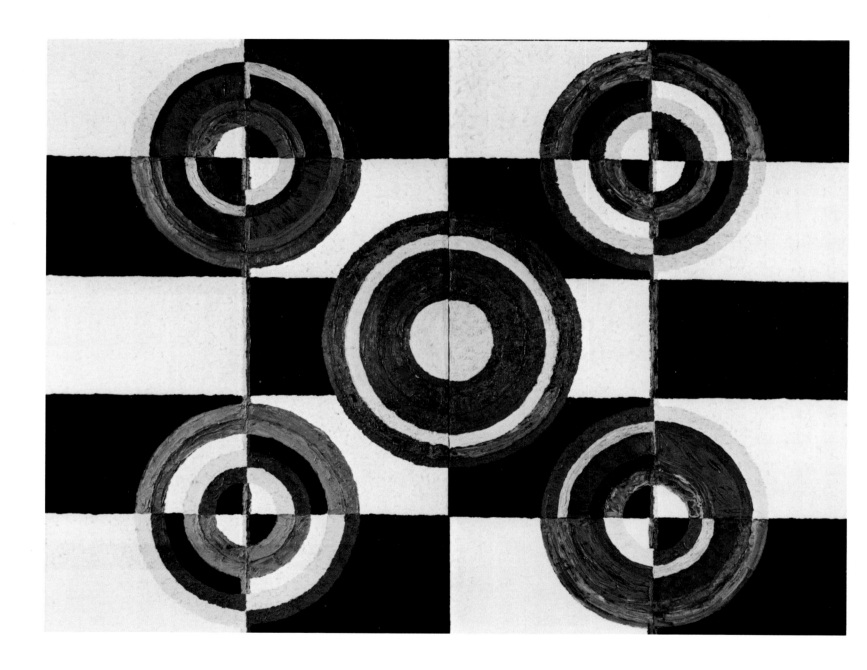

9. *Revolving Spheres,* 1959
 oil on canvas, 75 x 100

Study Black and White, 1959
oil on paper, 26¾ x 21½

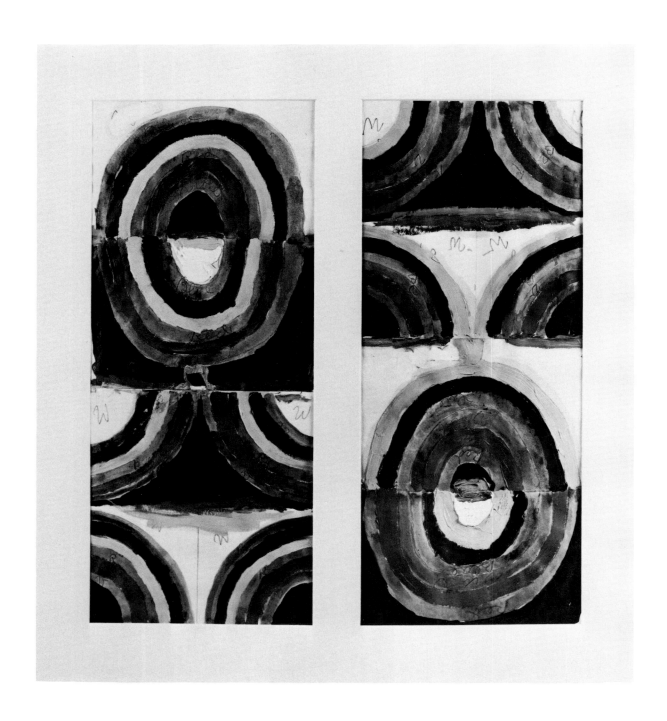

11. *Study in Color,* 1959
 oil on paper, 23½ x 22½

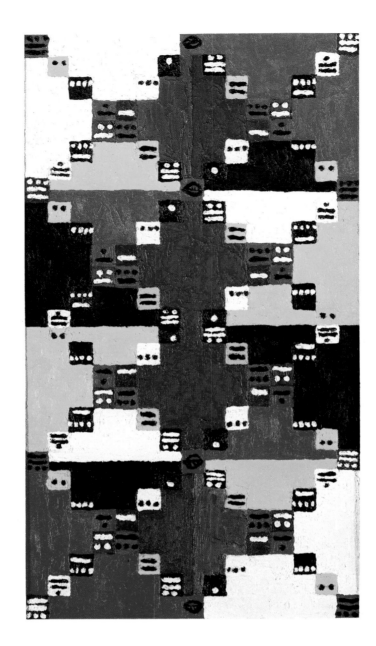

Magic 26, 1960
oil on canvas, 54 x 30

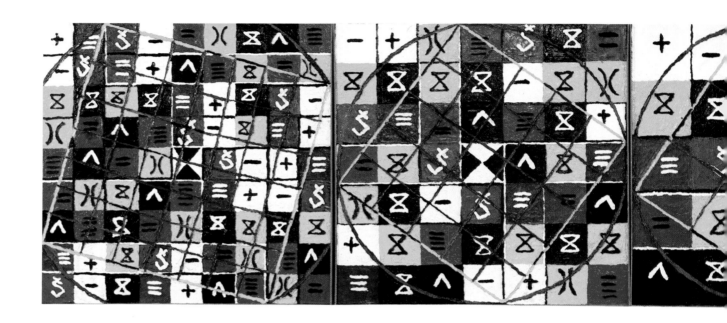

13. *Square Beginning – Cyclic Ending,*
 Per I, 80 Equivalent Squares of Value 5
 Per II, 48 Equivalent Squares of Value 5
 Per III, 24 Equivalent Squares of Value 5
 Per IV, 9 Equivalent Squares of Value 5
 Per V, 1 Square Area of Value 5, 1960
 oil on canvas, 50 x 250

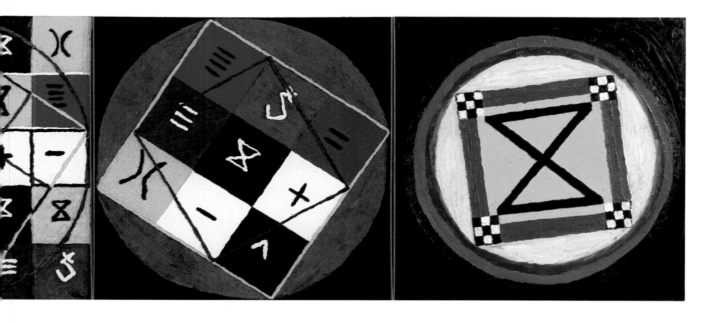

44

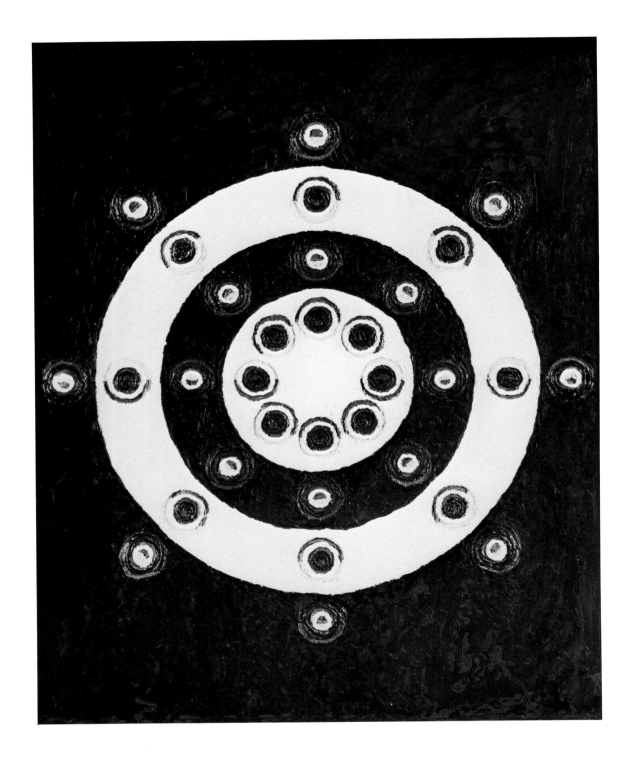

14. *Aurora, Per VI, Motion in Coloristic Orbits,* 1961
 oil on canvas, 68 x 54

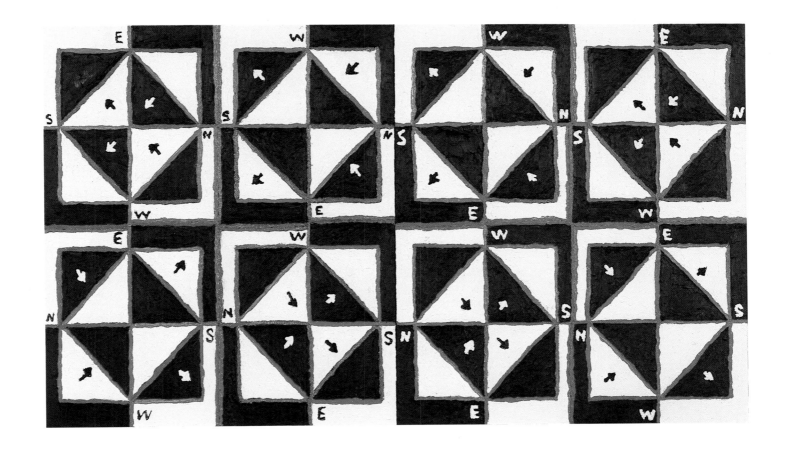

Correspondence in Function of Magnet and Prism,
Per I, Circuit of White Electrons
Per II, Circuit of Black Protons, 1961
Oil on canvas, 50 x 84

16. *A Film Ringed the Earth,* 1961
 ink and collage on paper, 22 x 28

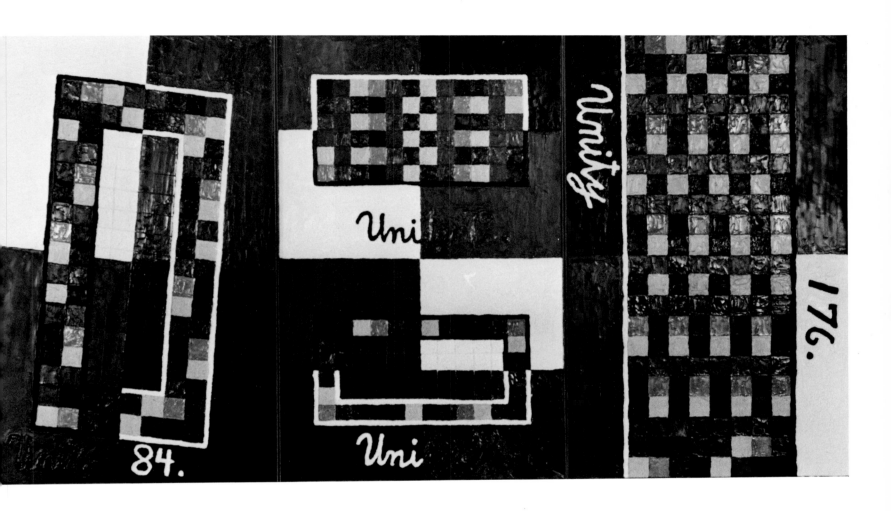

Athena, Hephaistos Above; Aphrodite Below,
Marduk, 1962
Oil on canvas, 66 x 123

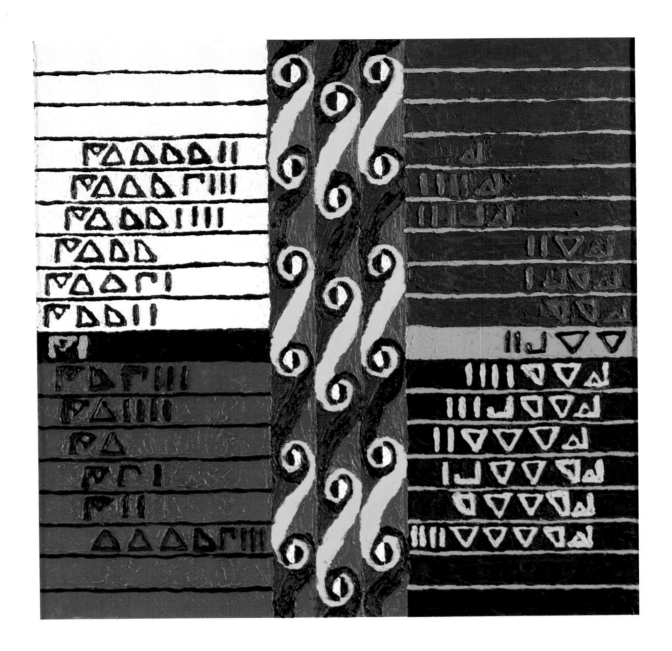

18. *Doric Order,* 1962
 oil on canvas, 54 x 54

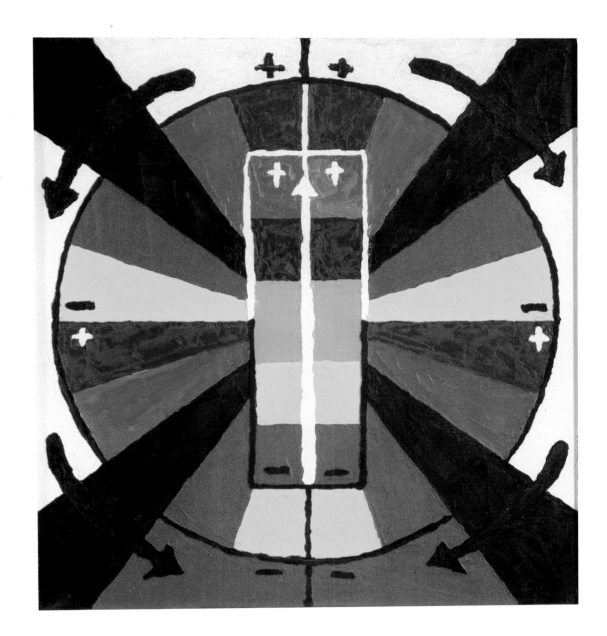

ast Sun. Perpetual Motion, 1962

l on canvas, 51 x 46

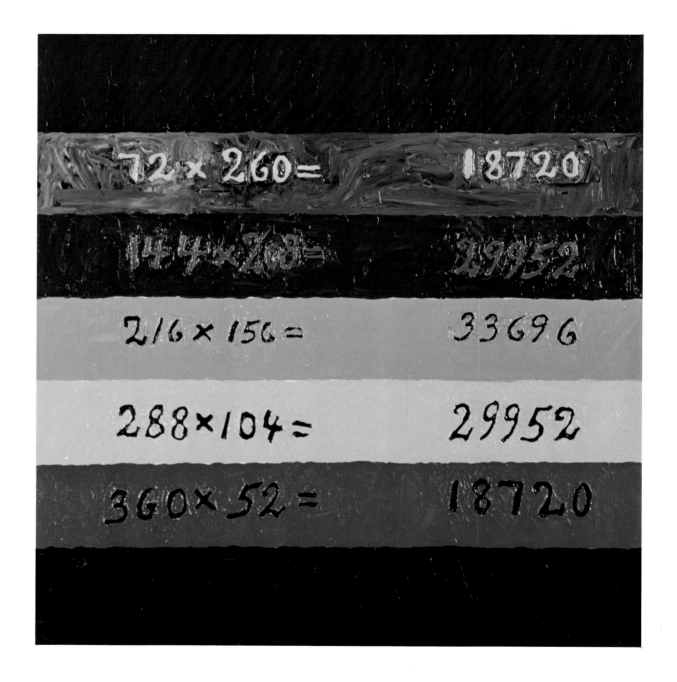

20. *The Light Color Notes,* 1962
oil on canvas, 52 x 50

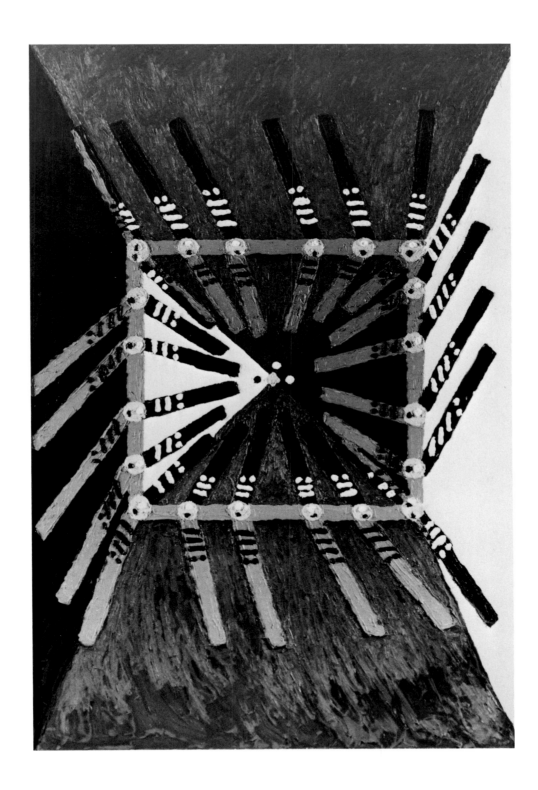

Mayan Temple, Per IV, Teotihuacan, 1962
oil on canvas, 76 x 50

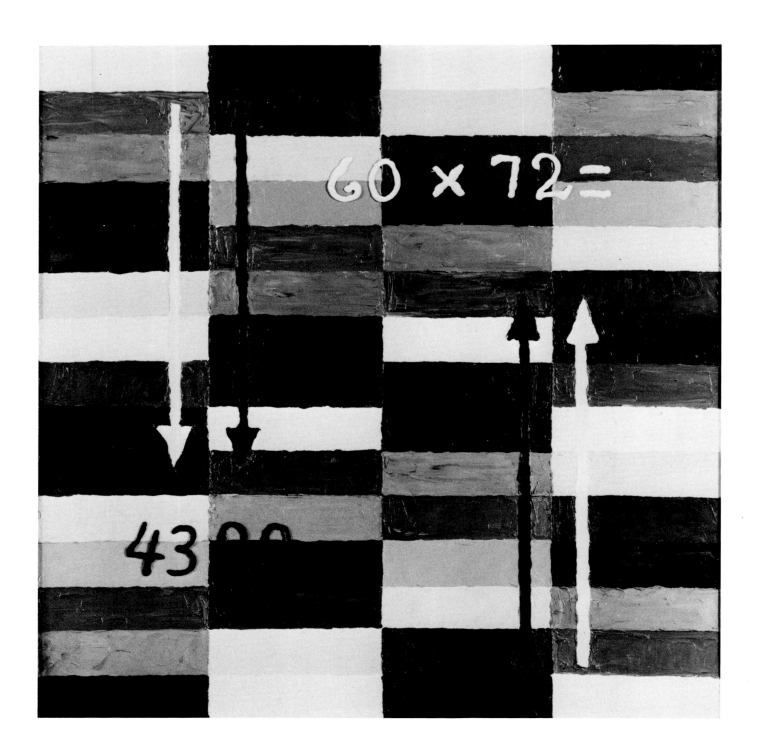

22. *Sixty Keys,* 1962
oil on canvas, 52 x 50

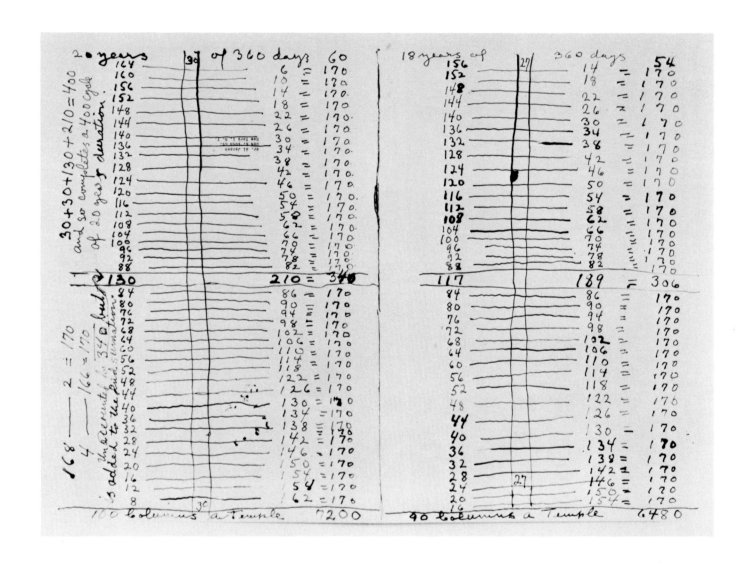

0 Columns of a Temple, 1962
k on paper, 22 x 23

24. *Men and Horses*, 1963
 oil on canvas, 50 x 198

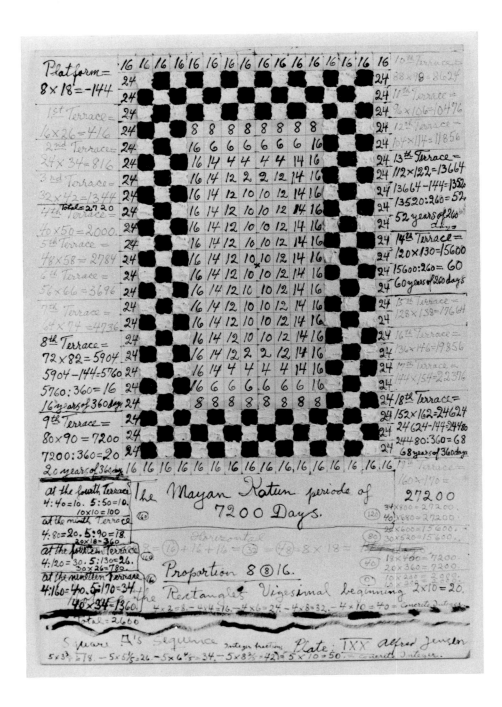

25. *Katun*, 1964
 oil on paper, 30 x 20

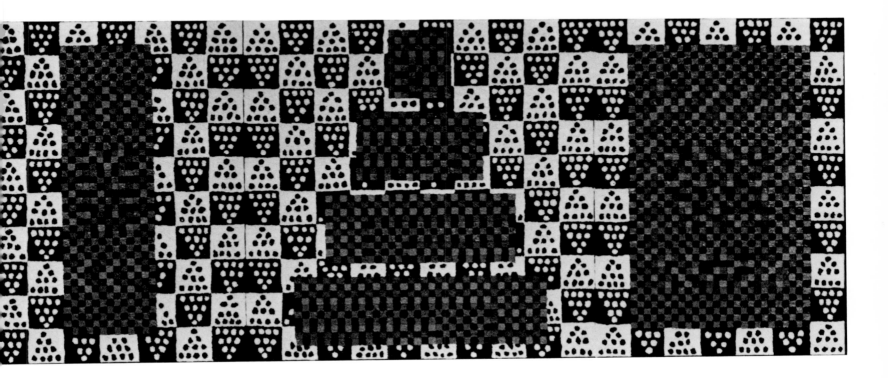

he Tetractys, 1964
l on canvas, 52 x 122

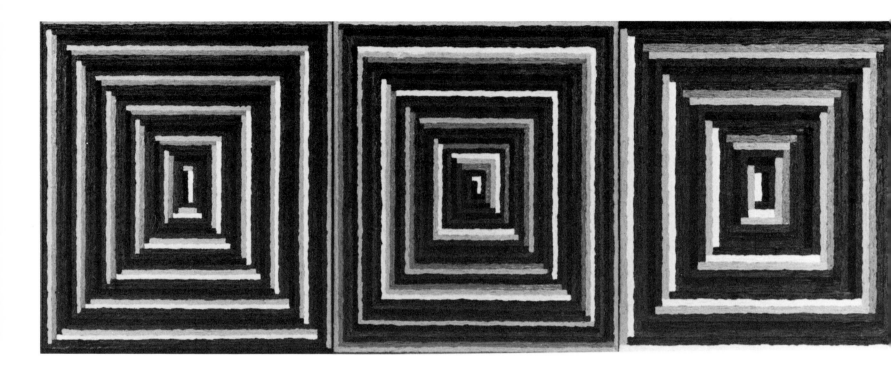

27. *Beat of Time*, 1966
 oil on canvas, 50 x 126

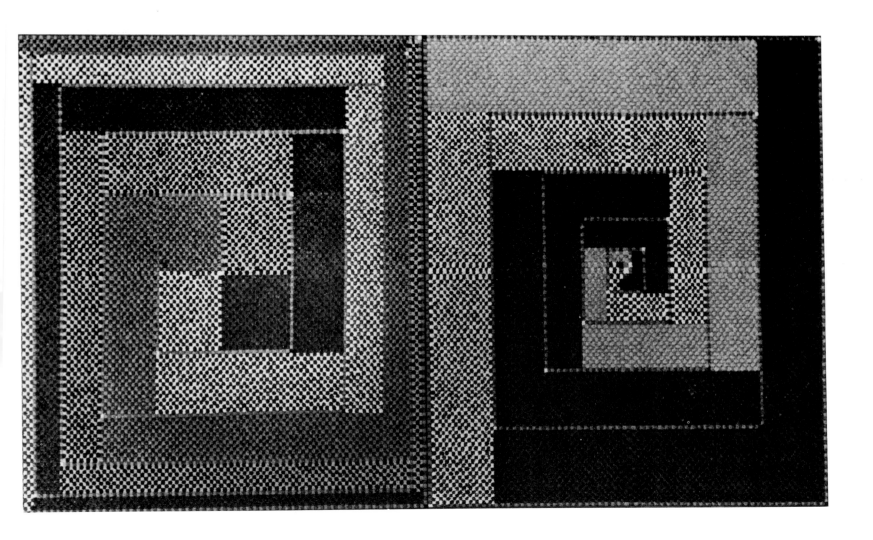

Timaeus, Per I and Per II, 1966
il on canvas, 60 x 100

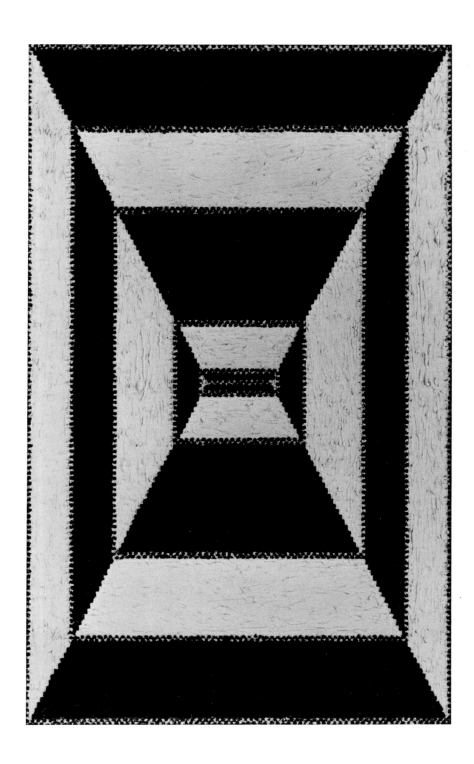

29. *The Acroatic Rectangle, Per Three,* 1967
 oil on canvas, 62½ x 37

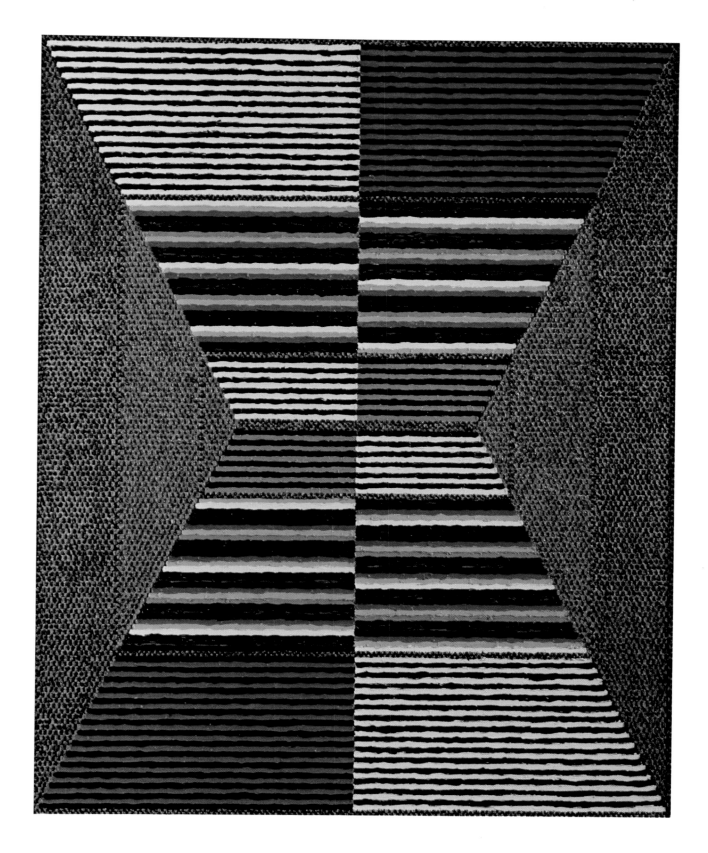

The Acroatic Rectangle, Per Thirteen, 1967
oil on canvas, 74 x 59

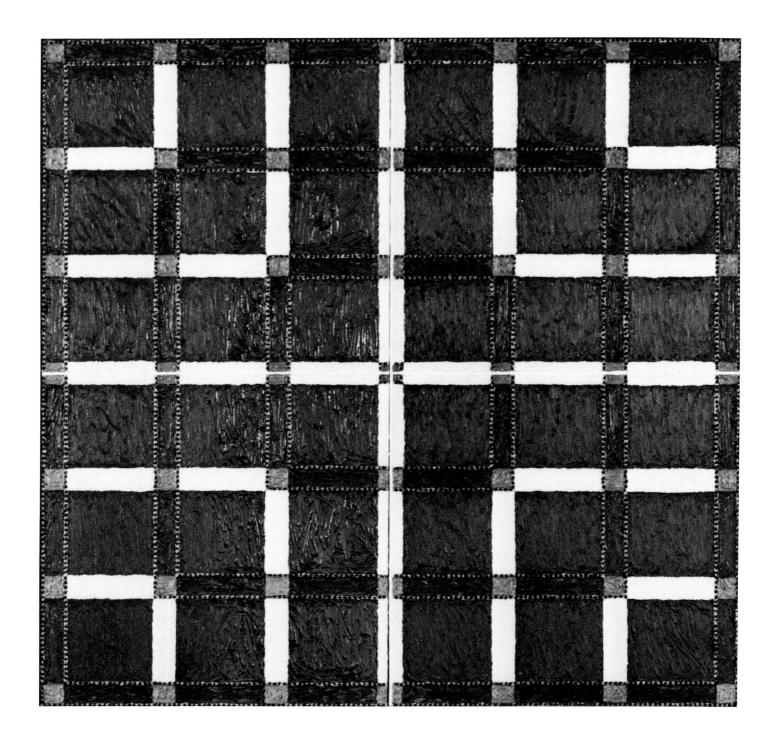

31. *Unity in the Square, Per I and Per II*, 1967
oil on canvas, 70 x 70

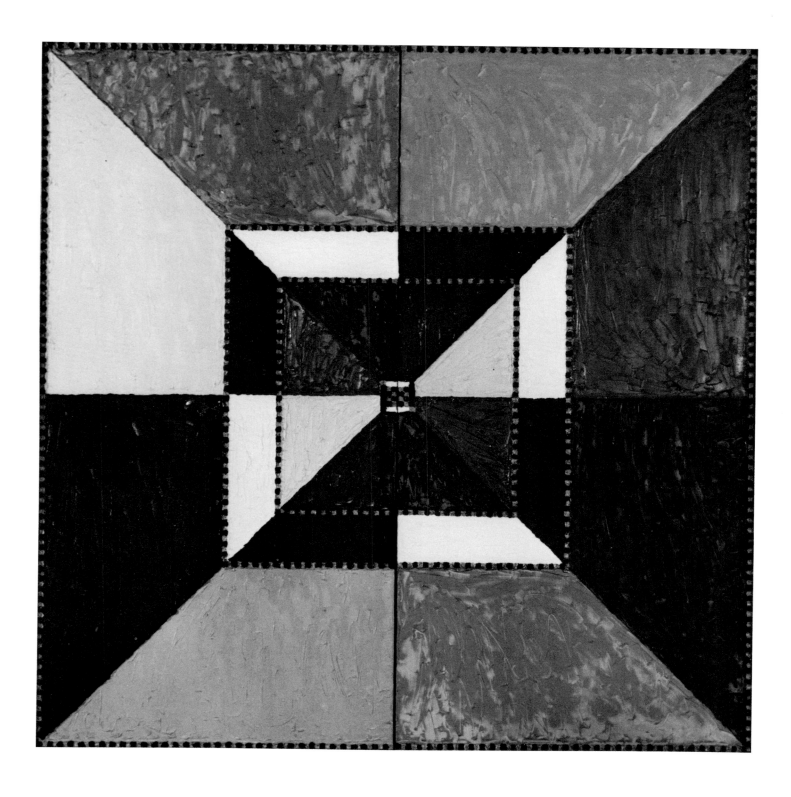

Square 6 Growth, 1968
il on canvas, 68 x 68

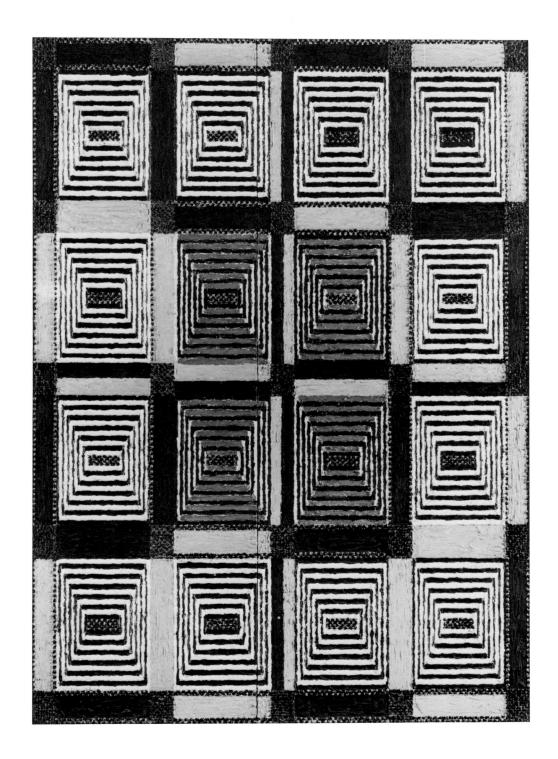

33. *Study for Mural at Albany Mall, New York,* 1968
 oil on canvas, 68¼ x 17¼

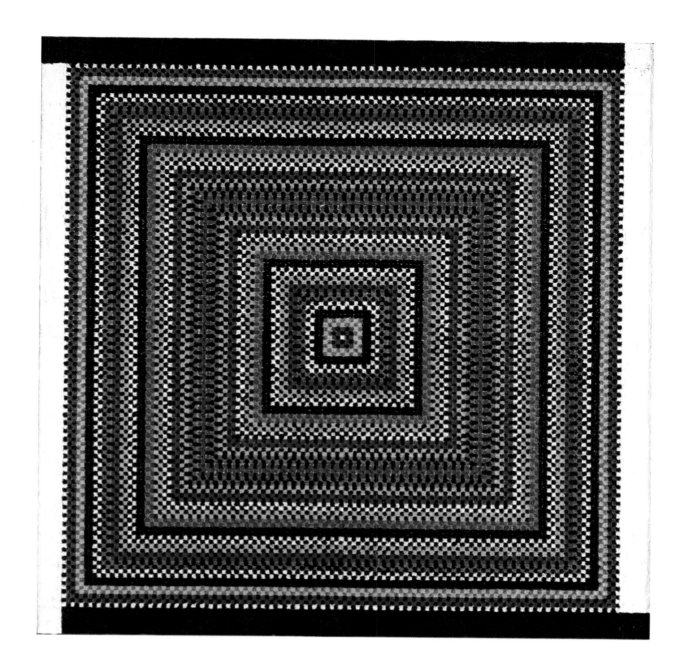

eciprocal Relation, Per 1 and Per 2, 1969
l on canvas, 71 x 71

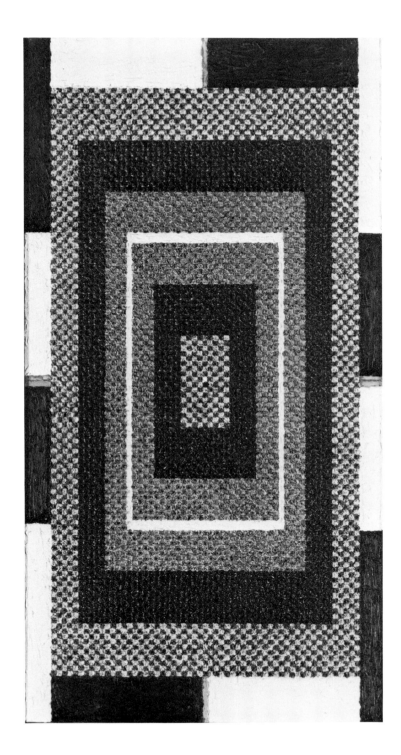

35. *Study of a Rectangle,* 1970
oil on canvas, 66½ x 33¼

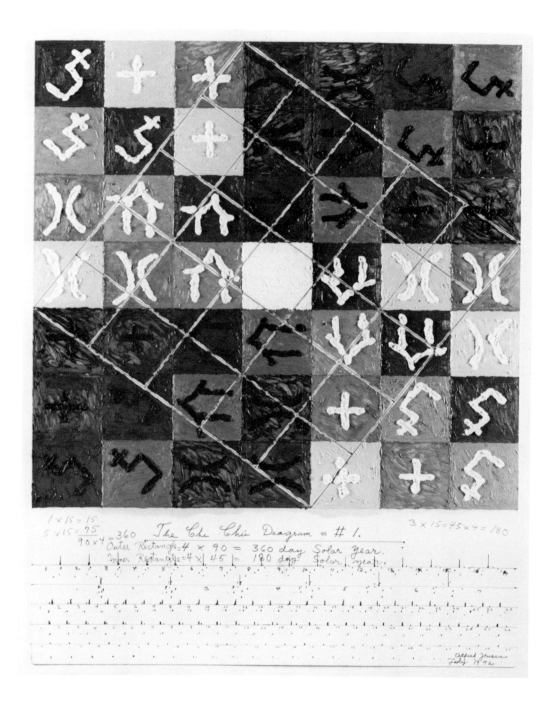

The Chi Chu Diagram #1, 1972
Oil on matboard, 30 x 20

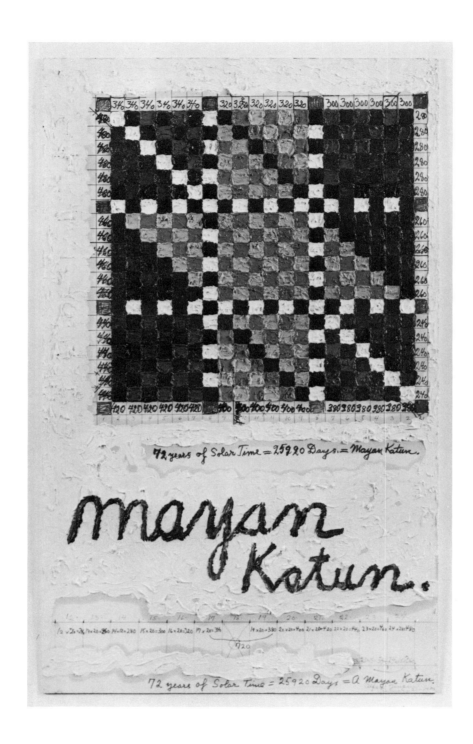

37. *Mayan Katun*, 1973
oil on matboard, 30 x 18

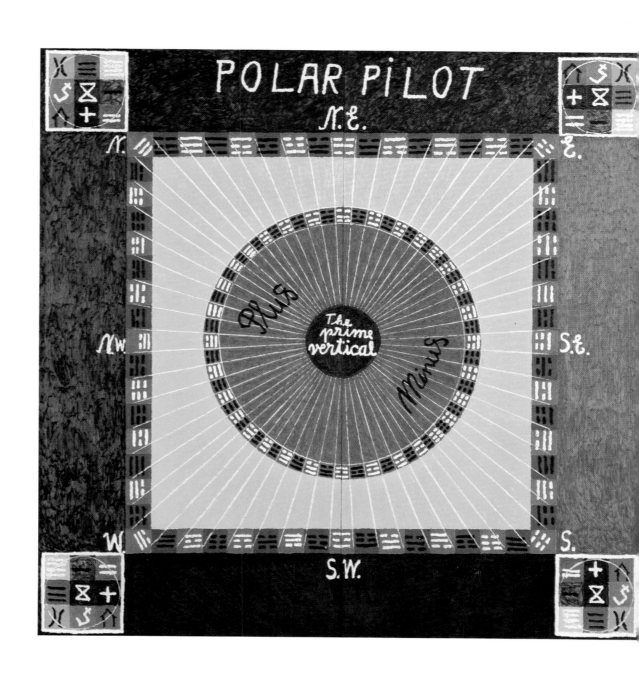

The Sun Rises Twice, 1973
il on canvas, 96 x 192

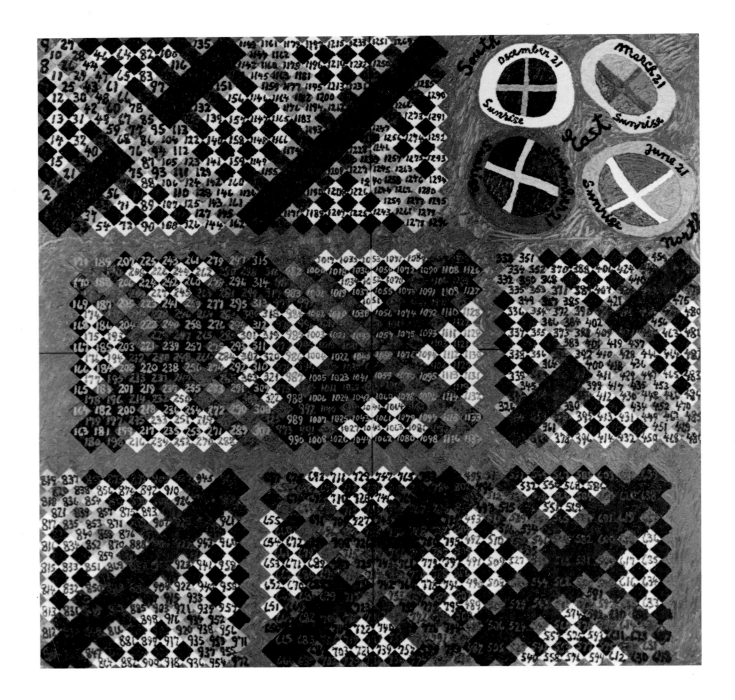

39. *The Earth's North-East-South*, 1974
oil on canvas, 90 x 90

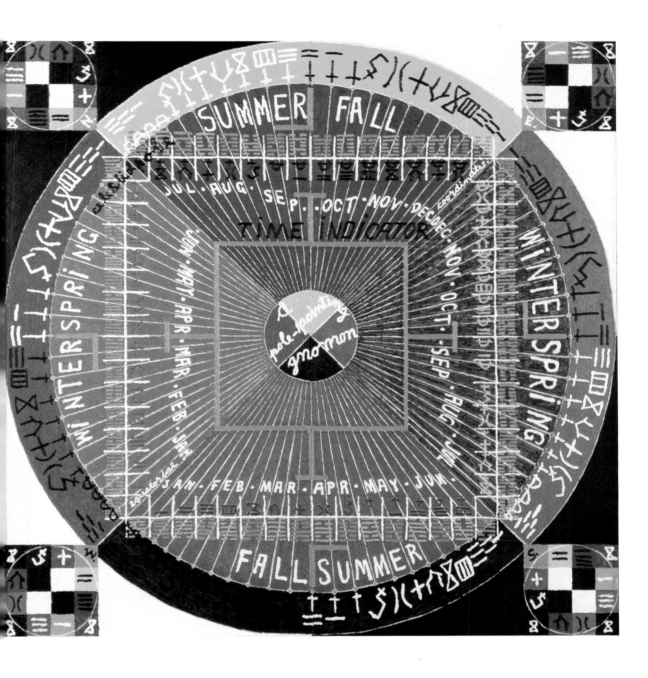

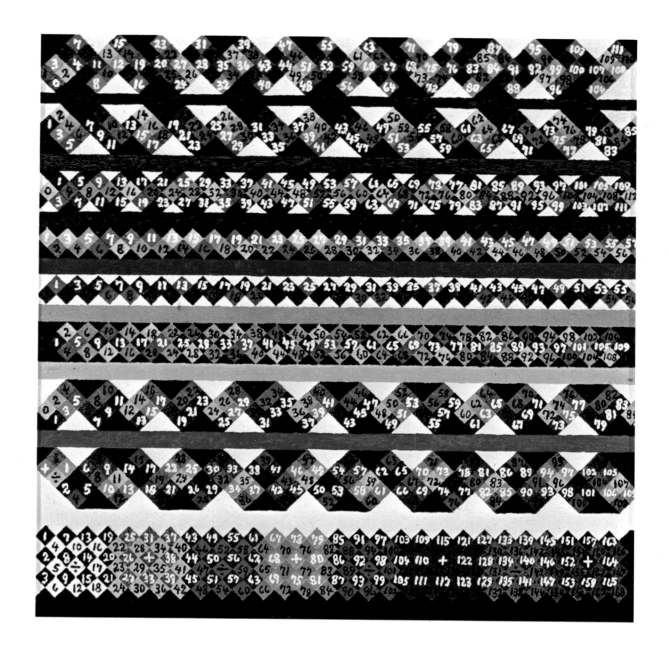

Mayan Mat Patterns Number Structures, 1974
il on canvas, 72 x 72

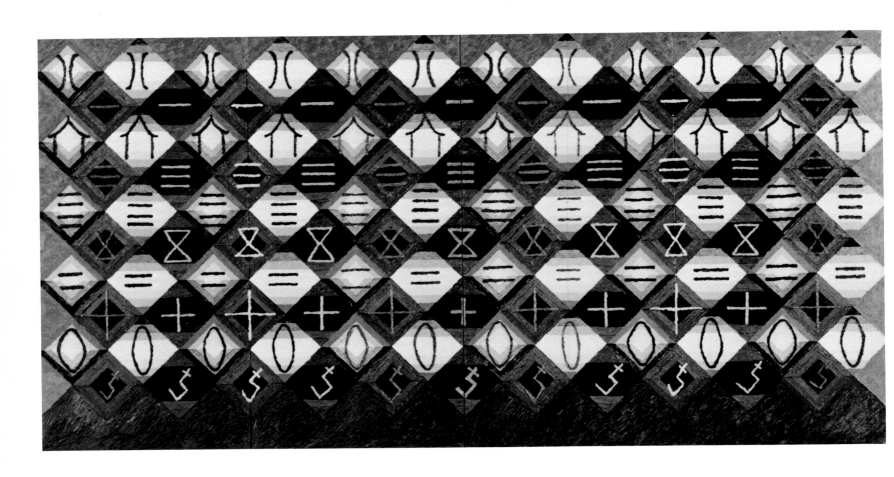

41. *Au Debut Du Printemps,* 1975
 oil on canvas, 74 x 148

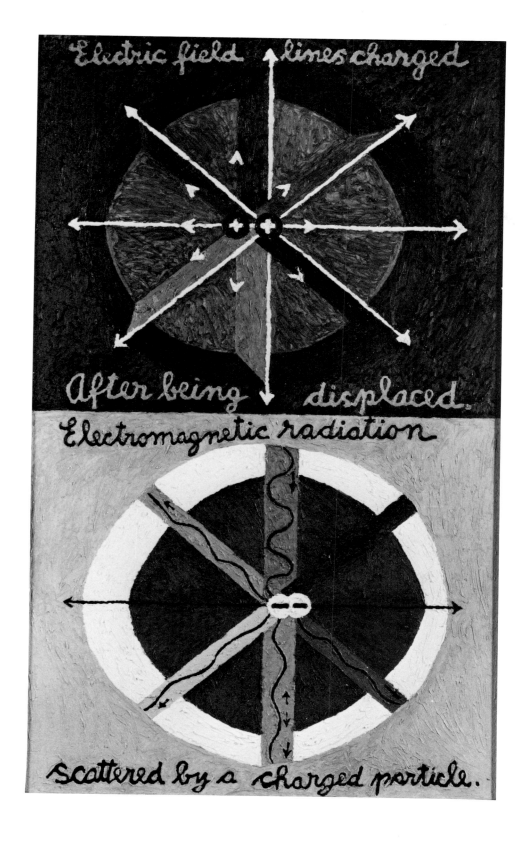

lectromagnetic Charge, 1975
il on canvas, 86 x 51

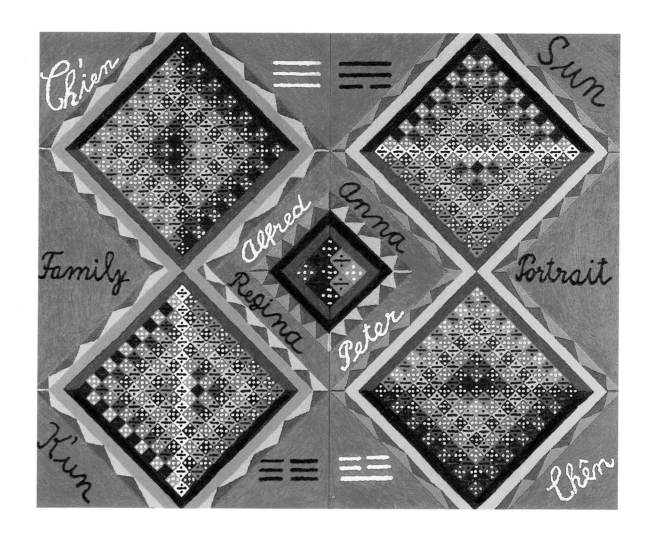

43. *The Family Portrait*, 1975
 oil on canvas, 86 x 102



75

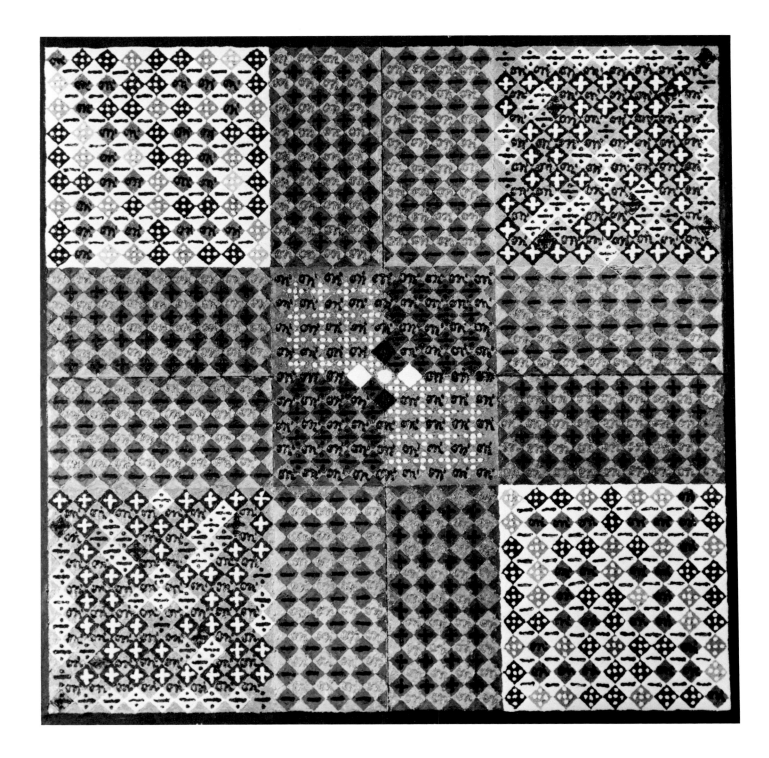

*he Marriage of Universal Darkness and Solar Light*
n Earth, 1975
l on canvas, 70 x 70

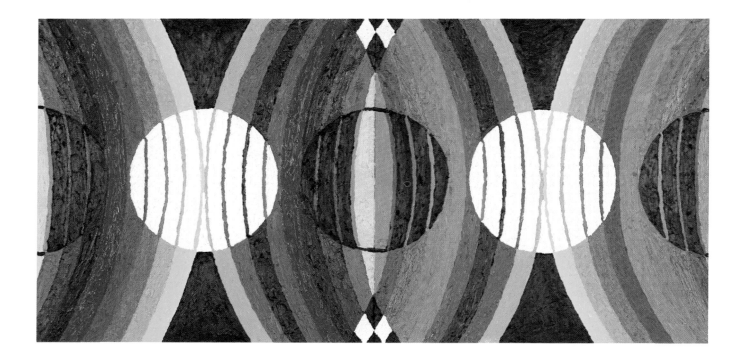

45. *Mr. Faraday's Diagram,* 1975
 oil on canvas, 35 x 70

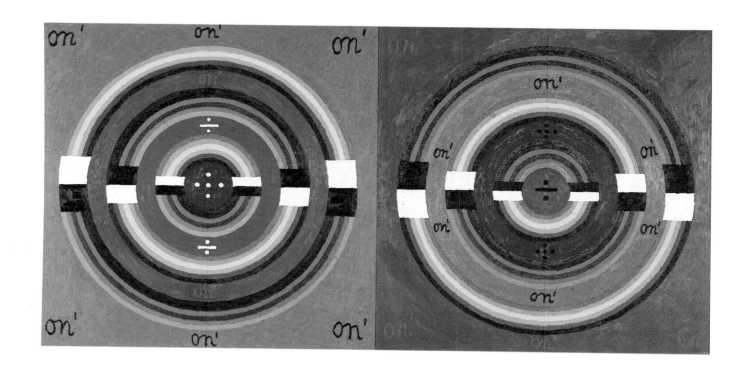

Negative Optic Electric Force, Positive Optic Electric Force, 1975
... on canvas, 70 x 140

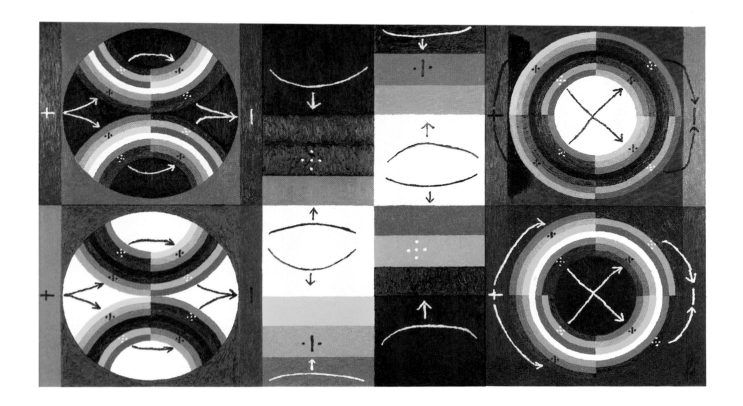

47. *Physical Optics,* 1975
 oil on canvas, 86 x 153

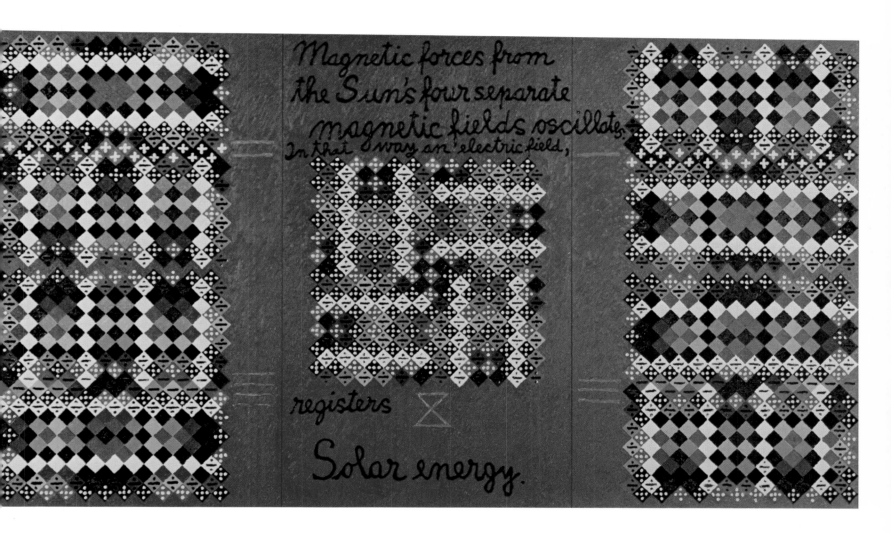

Solar Energy Optics, 1975
oil on canvas, 86 x 153

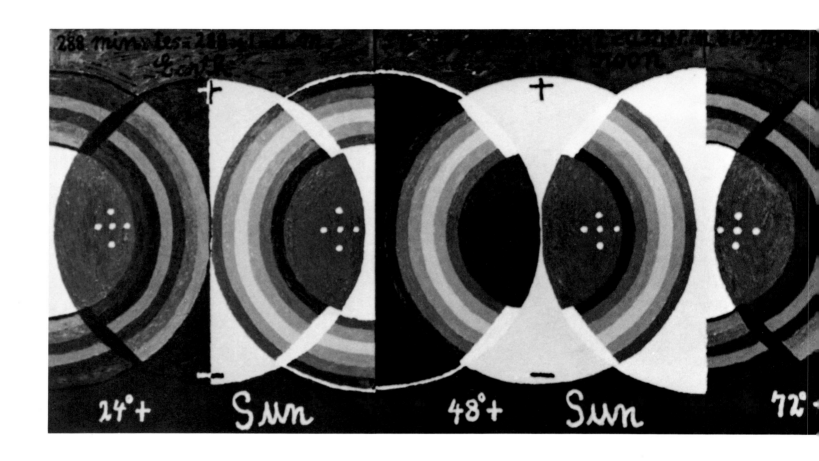

49. *Spectral Timing*, 1975
 oil on canvas, 51 x 255

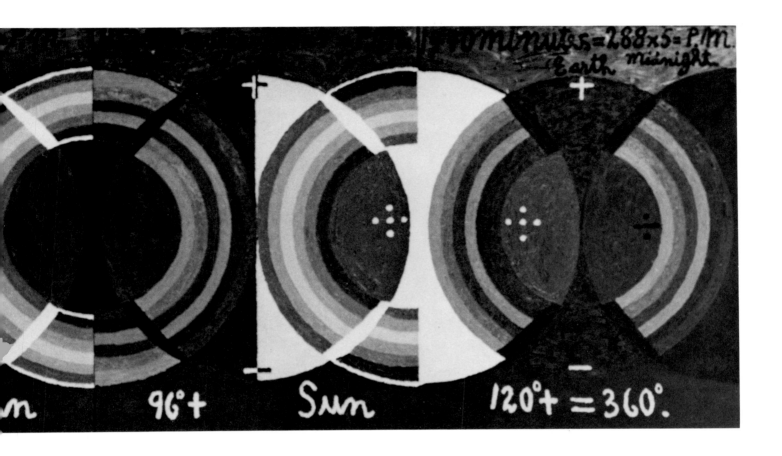

minutes = 288 × 5 = P/m.
Earth midnight

n 96°+ Sun 120°+ = 360°.

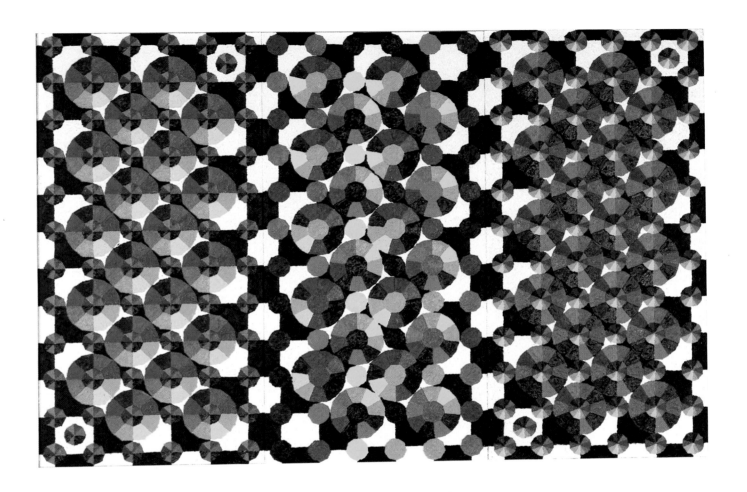

50. *Taj Mahal, #8, #9, #10,* 1975
 oil on canvas, 70 x 105

Reconciliation.

LO

2 = 15
7 = 15
6 = 15

ing.

HST.

5 6 8
3 4 10
1 2 12
0

#Eleventh Square
201 219 · · 842
203 217 204 218 · 842
205 215 206 214 · 842 · 4210
207 213 206 214 · 842
209 211 · · · 842

222 · · 211 240 · 922
223 237 224 238 · 922
225 235 226 236 · 922 · 4610
227 233 228 234 · 922
229 231 230 232 · 922

#Thirteenth Square
241 259 · · 1002
243 257 · · 1002
245 255 246 254 · 1002 · 5010
247 253 248 254 · 1002
249 251 250 252 · 1002

#Fourteenth Square
261 279 262 280 · 1082
263 277 264 278 · 1082
265 275 266 276 · 1082 · 5410
267 · · 268 274 · 1082
· 270 272 · 1082

#Fifteenth Square
281 299 282 · 1162
283 297 284 298 · 1162
285 295 286 296 · 1162 · 5810
287 293 288 294 · 1162
289 291 290 292 · 1162

301 319 302 320 · 1242
303 317 304 318 · 1242
305 315 306 316 · 1242 · 6210
307 313 308 314 · 1242
309 311 310 312 · 1242

#Seventeenth Square
321 339 · · 1322
323 337 324 338 · 1322
325 335 326 336 · 1322 · 6610
327 333 328 334 · 1322
329 331 330 332 · 1322

#Eighteenth Square
341 359 342 360 · 1402
343 357 344 358 · 1402
345 355 346 356 · 1402 · 7010
347 · 348 354 · 1402
· 350 352 ·

#Nineteenth Square
361 379 · · 1482
363 377 364 378 · 1482
365 375 366 376 · 1482 · 7410
367 373 368 372 · 1482
369 371 370 372 · 1482

381 399 382 400 · 1562
383 397 384 398 · 1562
385 395 386 396 · 1562 · 7810
387 393 388 394 · 1562
389 391 390 392 · 1562

of a horse, rose from the water, being marked on the back so as to give that first of the sages the idea of his diagrams. Confucius indorses these fables.

#1st Series	#2nd Series	#3rd Series	#4th Series	#5th Series
1 + 40 =	41 + 80 =	81 + 140 =	121 +	161 + 200 =
3 + 38 = 20	43 + 78 = 20	83 + 118 = 20	123 + = 20	163 + 198 = 20
5 + 36 =	45 + 76 =	85 + 116 =	125 + =	165 + 196 =
7 + 34 = X	47 + 74 = X	87 + 114 = X	127 + 154 = X	167 + = X
9 + =	49 + 72 =	89 + =	129 + 152 =	169 + =
11 + 30 = 41	51 + = 204	91 + 110 = 204	131 + = 20	171 + 190 = 36
13 + 28 =	53 + 68 = 12	93 + =	133 + =	173 + =
15 + 26 =	55 + 66 =	95 + 106 =	135 + =	175 + 186 =
17 + 24 = =	57 + 64 =	97 + 104 = =	137 + =	177 + 184 = =
19 + 22 = 8	59 + 62 = 2	99 + 102 =	139 + 142 = 5	179 + = 7
21 + = 8	61 + 60 = 2	101 + = 4	141 + 140 = 5	181 + = 7
23 + 18 = 2	63 + = 4	103 + 98 = 0	143 + = 6	183 + 178 = 2
25 + = 2	65 + 56 = 4	105 + 96 = 0	145 + 136 = 6	185 + = 2
27 + 14 = 0	67 + = 2	107 + 94 = 2	147 + = 2	187 + 174 = 2
29 + 12 = 0	69 + 52 = 2	109 + 92 = 2	149 + 132 = 2	189 + 172 = 2
31 + 10 = 0	71 + 50 = 0	111 + 90 = 0	151 + 130 = 0	191 + = 0
33 + =	73 + 48 = 0	113 + =	153 + 128 = 0	193 + =
35 + 6 =	75 + =	115 + 86 =	155 + 124 =	195 + 166 =
37 + =	77 + 44 =	117 + =	157 + 124 =	197 + =
39 + 2 =	79 + =	119 + 82 =	159 + =	199 + 162 =

the river sends forth no map: — it is all over with me!

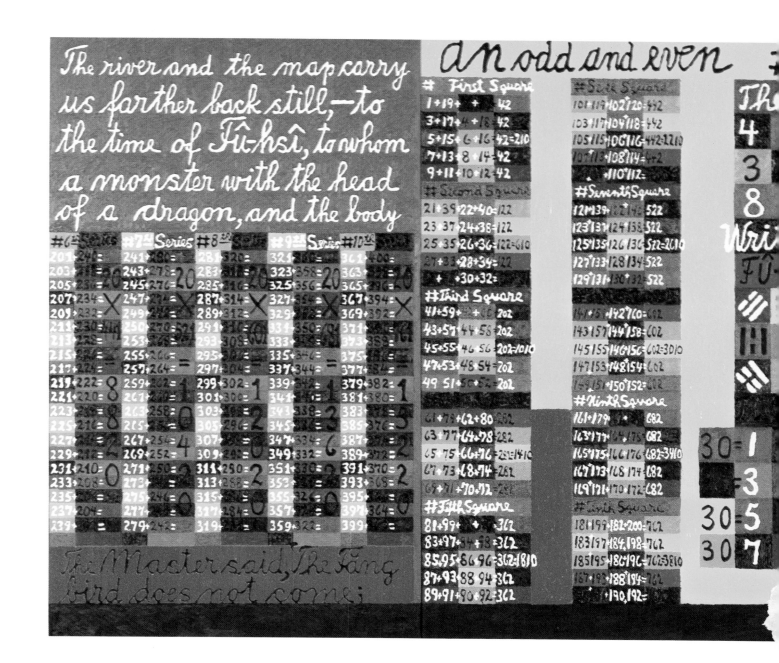

Divine Mission, 1976
...l on canvas, 86 x 204

84

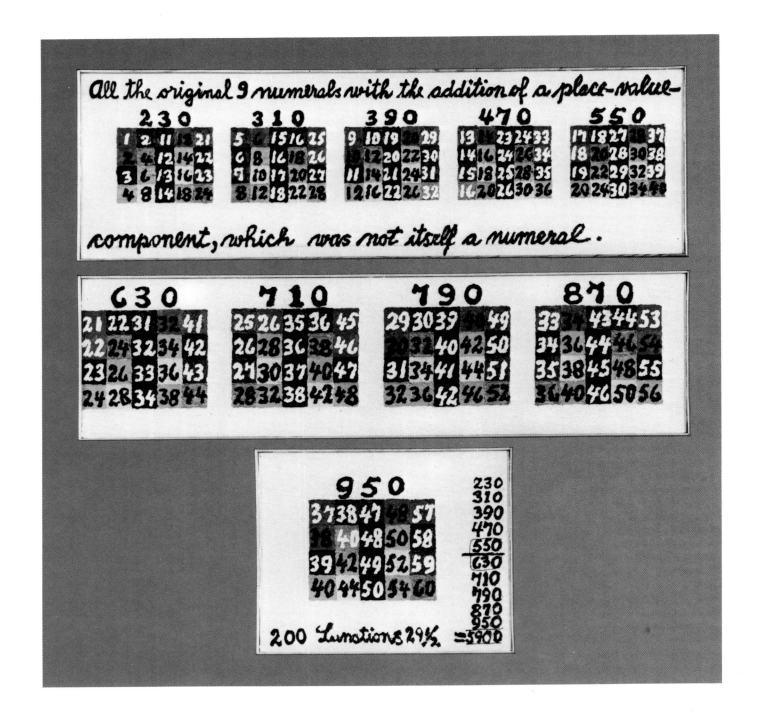

52. *A Place Value Component, Per I, Per II, Per III,* 1976
 oil on canvas,
 Per I, 15 x 48
 Per II, 13 x 48
 Per III, 16 x 20

rogression: Vertical 5, Horizontal 15, 1976

il on canvas, 51 x 86

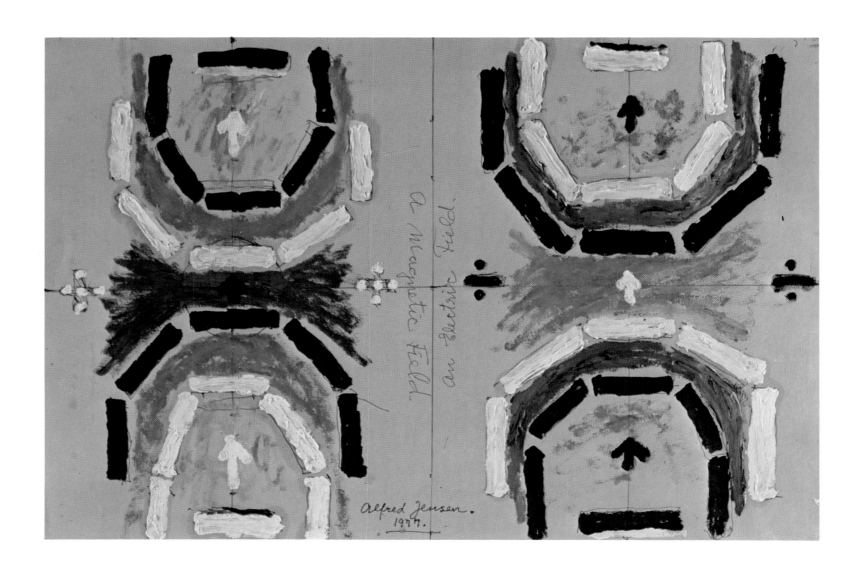

54. *Diagram for a Prism Machine,* 1977
 oil on paper, 20 x 30

The Sum of the Earthly Numbers is Thirty, 1977
Oil on matboard, 30 x 40

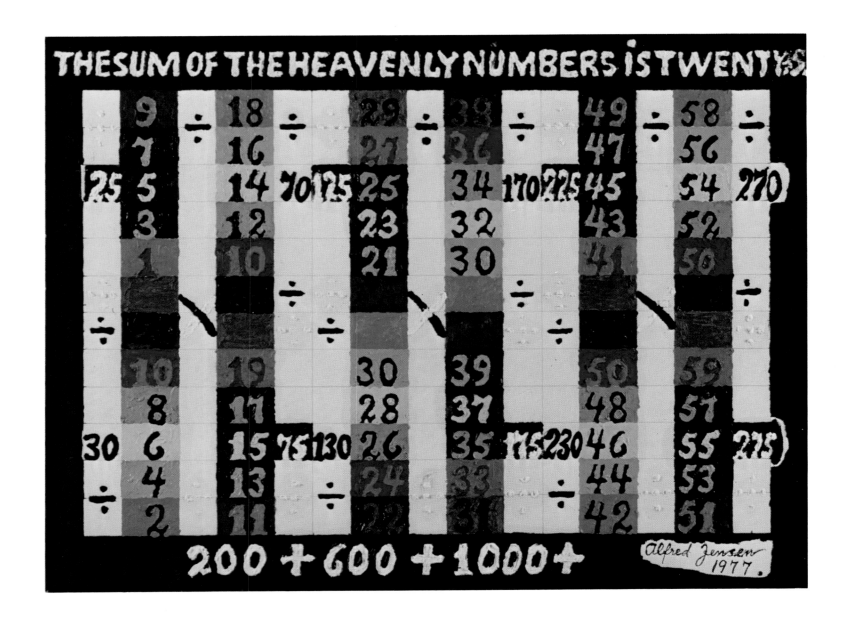

56. *The Sum of the Heavenly Numbers is Twenty-five,* 1977
oil on matboard, 30 x 40

Chronology

by Laura Justice Fleischmann

1903 Alfred Julio Jensen born December 11 in Guatemala City, the third of four children. His Danish father, Peter, had begun a building construction and furniture manufacturing business in Guatemala after abandoning plans to join the California Gold Rush. His mother, Anna, a German-Pole, settled in Guatemala having traveled there as governess to a French family.

1910 Mother dies and children are sent to school in Horsholm, Denmark, under their uncle's guardianship. Jensen begins drawing portraits of his classmates.

1917-1918 After graduation from school, Jensen is employed as cabin boy on a ship. He travels extensively and works as a seaman intermittently until 1926. He draws portraits of crews and passengers.
> *I listened to the wind and looked at the natural phenomena of life which is necessary to the development of an artist.* [1]

1919-1921 Learning his father is dying, Jensen leaves ship in San Francisco and begins to walk to Guatemala. He is prevented from entering Mexico and works in California as a cowboy and chicken farmer.
> *I was a chicken farmer and I was doing murals of my chickens . . . I drew in hundreds of chickens. I found that every chicken had its particular character* [2]

1922-1923 Arriving in Guatemala after his father's death, Jensen buys a farm with his brother. A small inheritance from his father augments Jensen's income.

1924-1925 Jensen sells his business interests and travels to California. Attends San Diego High School at night and works as a lumber salesman during the day. Receives a scholarship to the San Diego Fine Arts School at Balboa Park and attends under the direction of Eugene De Vol. Learning of Hans Hofmann's school in Munich and determined to enroll, he hires on a German ship.

1926 Jensen mistakenly attends Heymann's school in Munich.
> *I worked my way across as a sailor . . . when I arrived in Munich I couldn't remember the name . . . it was an "H" man, but I didn't know who it was* [3]

He meets the Americans Carl Holty and Vaclav Vytlacil who are students of Hofmann.
> *Heymann's class was being repainted . . . the whole of Heymann's students went to the Hofmann school to take drawing . . . There I found myself drawing between Vytlacil and Holty* [4]

After conversing with them, Jensen decides to join the Hofmann school. His work at this time concentrates on drawing after the old masters, particularly Bruegel and Dürer.
> *I had a big library of the old masters and I went to the Neue Pinakothek every Sunday religiously so I was schooling myself in the old masters.* [5]

1927-1937 In the fall of 1927 Jensen breaks with Hofmann who he feels is restricting his growth as an artist. Saidie Adler May, a wealthy art collector and student of Hofmann, offers her patronage to Jensen enabling him to continue his studies. At first reluctant, Jensen is encouraged by Vytlacil and subsequently enrolls at the Académie Scandinave in Paris in 1929. He studies modern sculpture with Charles Despiau and painting with Othon Friesz and Charles Dufresne, who becomes Jensen's "spiritual and painter-father." Saidie May enrolls at the Académie Scandinave in the same year. Jensen becomes her traveling companion and advisor to her collection. In 1929, they travel and paint in North Africa and Spain. In the early 1930s they begin travel throughout the major cities of Europe.
> *We copied two years in the Prado and brought our copies to be criticized by our French teachers, so we had the background – free copying, conversations with the old masters.* [6]

Mrs. May begins to collect modern French art.
> *I got in contact with all the great artists, Matisse, Giacometti, Miró, and we collected all these people and we visited the studios and bought right there* [7]

Jensen establishes permanent residence in the United States in 1934; thereafter, he and Mrs. May travel from there to Europe.

1938-1950 In 1938, Jensen visits André Masson at Lyon-la-Forêt.
> *We visited him . . . that was very important for me . . . He was one of the new spirits* [8]

While in France, Jensen becomes acquainted with the work and writing of Auguste Herbin; Herbin's interest in Goethe's color theory reinforces Jensen's thinking. Later that year he returns to the United States with May and they begin collecting contemporary American painting through dealers Rose Fried, Sidney Janis and Leo Castelli. During the war years Jensen and May travel to North Carolina, California and Chicago visiting artists' studios; they acquire little at this time however. After 1945 they begin to collect again — works by Paul Klee, Vassily Kandinsky, Theo van Doesburg, Naum Gabo and Fritz Glarner are added to the collection. Jensen is in the process of reading Goethe's *Zür Farbenlehre,* a study of color theory, which will occupy him for the next twenty years. He begins making diagrams from his Goethean studies which he considers researches into light and color rather than art. In 1946 Castelli introduces Jensen to Gabo and under his influence Jensen experiments briefly with constructivist sculpture.

1951 Saidie May dies and Jensen travels briefly to California. Her collection (a promised gift) goes to the Baltimore Museum of Art. He settles in New York and begins to concentrate exclusively on painting. Jensen's studio is in the Lincoln Arcade where his neighbor is Ulfert Wilke. Wilke introduces Jensen to James Johnson Sweeney, Director of the Guggenheim Museum; Sweeney visits Jensen's studio. Jensen executes a number of portraits and also paints representational landscapes, still lifes and figures in an abstract expressionist manner.

1952- Jensen meets Mark Rothko and a long-lasting
1953 friendship develops. Has first one-artist show at John Heller Gallery, New York, an exhibition of twelve canvases. These paintings are based on his study of Goethe's color theory which resulted in a change of palette to prismatic colors (the artist's term for those colors found in the light and dark spectrums of the prism). Exhibition receives favorable critical attention.

> *. . .one can appreciate these paintings for their strong, substantial composition and the glowing effect of primary color combinations . . . Jensen's canvases show his positive qualities as a painter.* [9]

Jensen meets Lil Picard, art critic, painter and sculptor, and a ten-year friendship begins. In 1953, he moves to a studio on East 10th Street.

1954- In 1954 Jensen is included in a three-artist show at
1956 the Tanager Gallery with sculptor Robert Becker and painter Sally Hazelet. Jensen meets Sam Francis in 1955 and a mutual exchange of ideas develops between them. Jensen is invited to participate in the Stable Gallery, New York, annual group shows with artists such as Franz Kline, Joseph Cornell, Willem de Kooning and Robert Rauschenberg. These groups exhibitions are important to Jensen's development and his understanding of his contemporaries' work.

First one-artist show is at Tanager Gallery in 1955; in 1956 Jensen joins the Bertha Schaefer Gallery for a brief period.

1957 Jensen begins to paint murals incorporating checkerboards and prismatic colors. He develops the idea of his diagrams into paintings on paper which investigate the logic for his compositions on canvas. The diagrams become works of art in themselves.

> *I was unconsciously doing my style for ten years but didn't know a painting could look that way.* [10]

Calligraphy, previously used in the diagrams, begins to appear in the paintings. He is extremely prolific during this time. Henry Luce III acquires *Why Hast Thou Forsaken Me* from the Bertha Schaefer Gallery, beginning a friendship which continues to the present. The painting is executed in the artist's newly matured style.

> *I knew that the prism held the clue that would enable me to arrive at an understanding of the genesis of color . . . the black and white mirror process in the prism paralleled that in the atmospheric dome and this led to the idea of the checkerboard image.* [11]

Sam Francis brings Arnold Rüdlinger, Director of the Kunsthalle, Basel, to Jensen's studio on 10th Street. Rüdlinger later organizes an exhibition in Winterthur, Switzerland and includes Jensen's work. Jensen sells his first work from this show. He destroys a number of sketches and diagrams but is restrained by Rothko's protest. With the breakthrough to the checkerboard image a very active period in Jensen's career begins.

1958 Jensen teaches summer session at the Maryland Institute, Baltimore.

1959 Martha Jackson visits his studio and invites Jensen to join her gallery. He meets Gerome Goodman who becomes an important collector and friend. Luce commissions Jensen to paint a mural for the Time/Life building in Paris; called *The Title Makers* the mural was destroyed by fire in 1967.

1960- Jensen begins to exhibit in important group shows
1962 throughout the country. Although he retains an individual style, his work is exhibited with the abstract expressionists and geometric abstractionists. He reads J. Eric S. Thompson's *Maya Hieroglyphic Writing* in 1960 which recalls to him his childhood in Guatamala and provides additional thematic interests for his work. There is much artistic production at this time. In 1961 he has his first major one-artist show at the Guggenheim Museum. Through the introduction of Rüdlinger, he joins the Kornfeld & Klipstein gallery, Bern.

1963 Jensen marries the painter Regina Bogat in New York. Has his first European exhibition at Kornfeld & Klipstein gallery, Bern, in October. Executes a series of paintings superimposing figurative elements of prismatic colors on checkerboards of black and white or, reversely, figurative elements in black and white against a prismatic colored checkerboard.

1964 A two-artist exhibition with Franz Kline at Kunsthalle, Basel, is organized by Rüdlinger. A retrospective selection of sixty of his works is shown. The Jensens travel for six months to Italy, Egypt, Greece, and France. At the end of the trip, they spend six weeks in Switzerland painting in a loft above Kornfeld's exhibition area.

1965 First child, Anna, born. Spends summer as Tamarind fellow making twenty lithographs. The set, *A Pythagorean Notebook,* explores ancient architectural structures to which the artist applies Pythagorean number structures. The prints are grid patterns with writing and numbers at the borders. Also executes a series of gouaches entitled *Hekatompedon.* These drawings are based on an ancient Grecian ritual which was of a religious and thanks-giving nature.

1966- Jensen's paintings at this time are inspired by his
1967 previous trips to Europe and Greece.

1968- The Jensens make a trip to Guatemala, Yucatan
1970 and Mexico, where much travel is done by airplane. Paintings inspired by aerial vision are comprised of concentric bands of small checkerboards. One-artist exhibition at Cordier & Ekstrom, New York, presents canvases executed in this motif. Jensen's interests turn to physics and astronomy. Reads the *I Ching* and J. Needham's *Science and Civilization in China* which has strong influence on his personal philosophy and provides thematic material for many paintings. Son, Peter, born in 1970.

1972 Family moves to Glen Ridge, New Jersey. Beginning his two year association with The Pace Gallery, New York, Jensen has a one-artist exhibition there during this year. Theme of the canvases exhibited centers on Jensen's interest in the *I Ching* and in the teachings of the Delphic Oracle.

> That they convey, in any case, a definite sense of conviction, beautifully exemplifying the principles they purport to expound, attests to their success as modern abstract paintings, scarcely needing the prop of a comparison to, say, Hindu yantras or Moorish mosaics, let alone a concordance of old lore. Jensen is, simply, a painter of wonderful skill and intensity. [12]

1973 Wieland Schmied, Director of the Kestner-Gesellschaft, Hanover, organizes a traveling exhibition of Jensen's work from the period 1957-1972. In 1973, Jensen writes of his paintings:

> The idea of correspondence has great significance and replaces the idea of causality, for things are connected rather than caused. Thus lovely things summon others among the class of lovely things, repulsive things summon others among the class of repulsive things. This arises from the complementary way in which a thing of the same class responds. This idea that things belonging to the same class resonate with or energize each other has guided me in producing my 1973 paintings. [13]

One-artist exhibition at The Pace Gallery, New York.

1974 During this year Jensen is preoccupied with the ancient quinary number system and the seasonal effects of the planets.

1975- Jensen's interest in number structures and
1976 dualities provides themes for numerous canvases. Studies the theory of paramagnetic phenomena vs. the diamagnetic approach as espoused by Michael Faraday, a 19th century physicist and chemist who discovered electromagnetic induction.

Exhibition of Jensen's work from 1961 to 1974 at The Pace Gallery, New York, 1976.

1977 Jensen paints the diagrams, *The Sum of the Heavenly Numbers is Twenty-Five* and *The Sum of the Earthly Numbers is Thirty*, which attempt a solution to *The Great Mystery II*, a work painted thirteen years earlier. *The Great Mystery II* is an irregular ground grid of black and white with superimposed Chinese numbers derived from Shang oracle bone forms of the 14th to 11th centuries B.C. The diagrams are mathematical explorations of the position and function of the "invisible 20" as realized through the working of *The Great Mystery II*.

His insight and his work have steadily grown; and there continue in him yearly floods of new thoughts, new discoveries, new connections for old thoughts that have been left dangling, and always with the enthusiasm and conviction we associate with youth.[14]

Footnotes

1. Leila Hadley Musham, "Alfred Jensen: Metaphysical and Primitive" (New York, 1975), unpublished, p. 15A.
2. Irving Sandler and Michael Torlen, Interview with Alfred Jensen (Glen Ridge, New Jersey, 15 May 1975), unpublished, n.p.
3. Linda L. Cathcart and Marcia Tucker, Interview with Alfred Jensen (Glen Ridge, New Jersey, 30-31 March 1977), unpublished.
4. Regina Bogat Jensen, Interview with Alfred Jensen (Glen Ridge, New Jersey, August 1977), unpublished, p. 10.
5. Ibid., p. 2.
6. Ibid., p. 6.
7. Sandler and Torlen, p. 9.
8. R. B. Jensen, p. 9.
9. M(artin) Z(wart), "Alfred Jensen," *Art Digest,* vol. 26, no. 11 (March 1952), p. 22.
10. R. B. Jensen, p. 24.
11. Musham, p. 9.
12. Peter Schjeldahl, "Ever Intimated by a Painting?" *New York Times* (28 May 1972), p. 17.
13. Alfred Jensen, "About My Work," *Alfred Jensen: Recent Paintings* (Pace Editions, Inc., New York, 1973), n.p.
14. A. Jensen, "Explanations for a Friend and Artist," *Alfred Jensen: The Aperspective Structure of a Square* (Cordier & Ekstrom, Inc., New York, 1970), n.p. Text based on a letter from Jensen to Allan Kaprow, 24 September 1969. Reprinted as "Jensen Mikro Makro," in *documenta 5: Internationale Ausstellung* (Museum Fridericianum, Kassel, 1972) and *Alfred Jensen* (Kestner-Gesellschaft, Hanover, 1973).

Exhibitions

One-Artist Exhibitions

1952 John Heller Gallery, New York. *Alfred Jensen: Experiments in Color,* March 17-29.

1955 Tanager Gallery, New York. *Al Jensen: Paintings,* October 21-November 10.

1957 Bertha Schaefer Gallery, New York. *Recent Oils by Alfred Jensen,* November 11-30.

1959 Martha Jackson Gallery, New York. *First Exhibition of Murals,* April 22-May 18.

Martha Jackson Gallery, New York. *Alfred Jensen and the Image of the Prism,* November 24-December 12.

1961 Martha Jackson Gallery, New York. *Magic Square,* January 17-February 11.

The Solomon R. Guggenheim Museum, New York. *Alfred Jensen,* August 30-October 8.

1963 Farleigh Dickinson University, Madison, New Jersey.

Graham Gallery, New York. *Duality Triumphant,* March 5-30.

Kornfeld & Klipstein, Bern. *Alfred Jensen,* October-November.

Graham Gallery, New York. *Divine Analogy and Time Reckoning,* November 5-December 7.

1964 Kunsthalle, Basel. *Alfred Jensen* (with *Franz Kline*), January 31-March 1.

Rolf Nelson Gallery, Los Angeles. *Alfred Jensen,* February 10-March 7.

Stedelijk Museum, Amsterdam. *Alfred Jensen,* May 15-July 5.

1965 Graham Gallery, New York. *Alfred Jensen,* March 30-April 24.

Rolf Nelson Gallery, Los Angeles. *A Pythagorean Notebook,* October 25-November 20.

1966 Galerie Renée Ziegler, Zurich. *Alfred Jensen,* March 31-April 30.

Royal Marks Gallery, New York. *Works of Graphic/Alfred Jensen,* April 19-May 4.

1967 Cordier & Ekstrom, Inc., New York. *The Acroatic Rectangle,* February 6-March 2.

Royal Marks Gallery, New York.

1968 Martha Jackson Gallery, New York. *Treasures from Inventory III,* January 16-31.

Cordier & Ekstrom, Inc., New York. *Alfred Jensen,* February 13-March 16.

J. L. Hudson Gallery, Detroit, Michigan. *Alfred Jensen: The Acroatic Rectangle,* May 14-June 8.

1970 Cordier & Ekstrom, Inc., New York. *The Aperspective Structure of a Square,* March 11-April 4.

1972 The Pace Gallery, New York. *Alfred Jensen, Paintings 1964-1972,* May 6-June 7.

Galerie Kornfeld, Zurich.

1973 Kestner-Gesellschaft, Hanover. *Alfred Jensen,* January 12-February 11 (circulated to: Louisiana Museum, Humblebaek, Denmark; Kunsthalle, Baden-Baden; Kunsthalle, Dusseldorf; Kunsthalle, Bern).

The Pace Gallery, New York. *Alfred Jensen: Recent Paintings,* October 27-November 24.

1975 Kunsthalle, Basel. *Alfred Jensen,* June 19-August 10.

Kornfeld & Klipstein ,Basel. *Alfred Jensen,* June 19-August 10.

1976 The Pace Gallery, New York. *Alfred Jensen: Selected Works 1961-1974,* January 10-February 7.

1977 Kornfeld & Klipstein, Basel. *Alfred Jensen* (with *Sam Francis*), October 1-December 18.

São Paulo, Brazil. *XIV International Bienal of São Paulo. Alfred Jensen: Paintings and Diagrams From the Years 1957-1977,* October 1-November 30.

Selected Group Exhibitions

1954 Stable Gallery, New York. *Third Annual Exhibition of Painting and Sculpture.*

1955 Stable Gallery, New York. *Fourth Annual Exhibition of Painting and Sculpture.*

1956 Stable Gallery, New York. *Fifth Annual Exhibition of Painting and Sculpture.*

Tanager Gallery, New York. *Painters/Sculptors on 10th Street.*

1960 The City Art Museum of St. Louis. *Collectors Choice.*

Dilexi Gallery, San Francisco. *Jensen and Schwitters.*

Institute of Contemporary Art, Boston. *The Image Lost and Found.*

Palacio de Bellas Artes, Mexico City. *Segunda Bienal Interamericana de Mexico, 1960.*

1961 The Solomon R. Guggenheim Museum, New York. *American Abstract Expressionists and Imagists.*

The Solomon R. Guggenheim Museum, New York. *100 Paintings from the G. David Thompson Collection.*

1962 The Art Institute of Chicago. *65th American Exhibition: Some Directions in Contemporary Painting and Sculpture.*

The Colorado Springs Fine Arts Center. *New Accessions U.S.A., 1962.*

Whitney Museum of American Art, New York. *Geometric Abstraction in America.*

1963 Corcoran Gallery of Art, Washington, D.C. *The 28th Biennial Exhibition 1963.*

Graham Gallery, New York. *Banners.*

National Gallery of Art, Smithsonian Institution, Washington, D.C. *Paintings From The Museum of Modern Art, New York.*

San Francisco Museum of Art. *Recent Trends.*

Whitney Museum of American Art, New York. *Annual Exhibition 1963: Contemporary American Painting.*

1964 American Federation of Arts Gallery, New York. *A Decade of New Talent* (circulated under the auspices of The American Federation of Arts).

Los Angeles County Museum of Art. *Post Painterly Abstraction* (circulated to Walker Art Center, Minneapolis and Art Gallery of Toronto).

Museum Fridericianum, Kassel. *documenta III: Internationale Ausstellung.*

Venice. *XXXII Esposizione Biennale Internazionale d'Arte Venezia: Selections from the Collection of The Solomon R. Guggenheim Museum.*

1965 Brown University, Providence, Rhode Island. *Kane Memorial Exhibition.*

Metropolitan Art Gallery, Tokyo. *The 8th International Art Exhibition of Japan* (circulated throughout Japan under the auspices of The American Federation of Arts).

San Francisco Museum of Art. *Colorists 1950-1965.*

San Francisco Museum of Art. *Highlights of 1964-65.*

1967 Graham Gallery, New York. *The Rainbow Room.*

1968 Albright-Knox Art Gallery, Buffalo. *Plus by Minus: Today's Half Century.*

Das Modern Art Museum, Munich. *Neue Kunst U.S.A. Barock-Minima.*

Kunstmuseum, Basel. *Sammlung Marguerite Arp – Hagenbach.*

Museum Fridericianum, Kassel. *4. documenta: Internationale Ausstellung.*

1969 Lafayette College, Easton, Pennsylvania. *Black-White.*

Museo Nacional de Bellas Artes, Buenos Aires, Argentina. *109 obras de Albright-Knox Art Gallery.*

The Museum of Modern Art, New York. *Tamarind: Homage to Lithography* (circulated under the auspices of the International Council of The Museum of Modern Art).

1970 The Aldrich Museum of Contemporary Art, Ridgefield, Connecticut. *Highlights of the 1969-70 Art Season.*

Indianapolis Museum of Art. *Painting and Sculpture Today.*

Virginia Museum of Fine Arts, Richmond. *American Painting 1970.*

1971 Whitney Museum of American Art, New York. *The Structure of Color.*

1972 Albright-Knox Art Gallery. *Recent American Painting and Sculpture in the Albright-Knox Art Gallery.*

The Gallery of the American Academy of Arts and Letters, New York. *Exhibition of Works by Contemporary Artists Who Are Not Members of the Institute.*

Institute of Contemporary Art, University of Pennsylvania, Philadelphia. *Grids Grids Grids Grids Grids Grids Grids Grids.*

Museum Fridericianum, Kassel. *documenta 5: Internationale Ausstellung.*

1973 University of Maryland Art Gallery, College Park. *The Private Collection of Martha Jackson* (circulated to The Finch College Museum of Art, New York and Albright-Knox Art Gallery, Buffalo).

Whitney Museum of American Art, New York. *1973 Biennial Exhibition: Contemporary American Art.*

1975 Albright-Knox Art Gallery, Buffalo. *The Martha Jackson Collection at the Albright-Knox Art Gallery.*

Museo de Arte Moderno, Mexico City. *Color* (in collaboration with the International Council of The Museum of Modern Art, New York).

University Art Gallery, State University of New York at Albany. *Selections from the Martha Jackson Gallery Collection.*

1976 The Solomon R. Guggenheim Museum, New York. *Acquisition Priorities: Aspects of Postwar Painting in America.*

1977 Philadelphia College of Art. *Time.*

San Francisco Museum of Modern Art. *Collectors, Collecting, Collection: American Abstract Art Since 1945.*

Whitney Museum of American Art, New York. *1977 Biennial Exhibition: Contemporary American Art.*

Public Collections

Albright-Knox Art Gallery, Buffalo, New York

The Aldrich Museum of Contemporary Art, Ridgefield, Connecticut

American Republic Insurance Company, Des Moines, Iowa

Chase Manhattan Bank, New York

The Dayton Art Institute, Dayton, Ohio

The Solomon R. Guggenheim Museum, New York

Herbert F. Johnson Museum of Art, Cornell University, Ithaca, New York

I.B.M., Armonk, New York

Kunstmuseum, Bern, Switzerland

Kunsthalle, Basel

Kunsthaus, Zurich

Louisiana Museum, Humblebaek, Denmark

Museum of Art, Carnegie Institute, Pittsburgh, Pennsylvania

The Museum of Modern Art, New York

Neue Galerie-Sammlung Ludwig, Aachen, Germany

Phoenix Art Museum, Phoenix, Arizona

Prentice-Hall Inc., Englewood, New Jersey

Rose Art Museum, Brandeis University, Waltham, Massachusetts

San Francisco Museum of Modern Art, San Francisco, California

The Seibu Museum of Art, Tokyo

Time, Inc., New York

Whitney Museum of American Art, New York

Bibliography

Catalogues: One-Artist Exhibitions

1952 John Heller Gallery, New York. *Alfred Jensen: Experiments in Color.*

1959 Martha Jackson Gallery, New York. *Alfred Jensen: Works of 1958-1959.* Text by the artist.

1961 The Solomon R. Guggenheim Museum, New York. *Alfred Jensen.*

1963 Kornfeld & Klipstein, Bern. *Alfred Jensen.* Texts by the artist and E. W. Kornfeld.

1964 Kunsthalle, Basel. *Alfred Jensen.*

Stedelijk Museum, Amsterdam. *Alfred Jensen.*

1966 Galerie Renée Ziegler, Zurich. *Alfred Jensen.* Texts by Max Bill and E. W. Kornfeld.

1970 Cordier & Ekstrom, Inc., New York. *Alfred Jensen: The Aperspective Structure of a Square.* Text by the artist.

1973 The Pace Gallery, New York. *Alfred Jensen: Recent Paintings.* Text by the artist.

Kestner-Gesellschaft, Hanover. *Alfred Jensen.* Texts by the artist, Max Bill, Allan Kaprow and Wieland Schmied.

1975 Kunsthalle, Basel. *Alfred Jensen.*

Kornfeld & Klipstein, Basel. *Alfred Jensen.*

1977 São Paulo, Brazil. *XIV International Bienal of São Paulo. Alfred Jensen: Paintings and Diagrams from the Years 1957-1977.* Texts by the artist, Linda L. Cathcart and Marcia Tucker.

Catalogues: Selected Group Exhibitions

1960 Palacio de Bellas Artes, Mexico City. *Segunda Bienal Interamericana de Mexico, 1960.*

1961 The Solomon R. Guggenheim Museum, New York. *American Abstract Expressionists and Imagists.* Text by H. H. Arnason.

The Solomon R. Guggenheim Museum, New York. *One Hundred Paintings from the G. David Thompson Collection.* Introduction by G. David Thompson.

1962 The Art Institute of Chicago. *65th Annual American Exhibition.*

The Colorado Springs Fine Arts Center. *New Accessions USA.* Introduction by Fred Bartlett.

Whitney Museum of American Art, New York. *Geometric Abstraction in America.*

1963 Corcoran Gallery of Art, Washington, D.C. *The 28th Biennial Exhibition 1963.* Introduction by Hermann Williams, Jr.

The Museum of Modern Art, New York. *Paintings from The Museum of Modern Art, New York.* Texts by Alfred H. Barr, Jr., René d'Harnoncourt, and John Walker.

San Francisco Museum of Art. *Recent Trends.*

Whitney Museum of American Art, New York. *Annual Exhibition 1963: Contemporary American Painting.*

1964 The Aldrich Museum of Contemporary Art, Ridgefield, Connecticut. *Highlights of the 1964-1965 Art Season.* Preface by Larry Aldrich.

Museum Fridericianum, Kassel. *documenta III: Internationale Ausstellung.* Texts by Arnold Bode and Werner Haftmann.

Los Angeles County Museum of Art. *Post Painterly Abstraction.* Texts by James Elliott and Clement Greenberg.

Venice. *XXXII Esposizione Biennale Internazionale d'Arte Venezia. Selections from the Collection of The Solomon R. Guggenheim Museum.* Introduction by Thomas M. Messer.

1965 San Francisco Museum of Art. *Colorists 1960-1965.* Introduction by Anita Ventura.

San Francisco Museum of Art. *Highlights of 1964-65.*

1968 Albright-Knox Art Gallery, Buffalo. *Plus by Minus: Today's Half-Century.* Essay by Douglas MacAgy.

Museum Fridericianum, Kassel. *4. documenta: Internationale Ausstellung.*

1969 The Museum of Modern Art, New York. *Tamarind: Homage to Lithography.* Texts by Virginia Allen and William S. Lieberman.

1970 The Aldrich Museum of Contemporary Art, Ridgefield, Connecticut. *Highlights of 1969-1970 Art Season.* Preface by Larry Aldrich.

Indianapolis Museum of Art. *Painting and Sculpture Today.* Texts by Richard L. Warrum and Carl J. Weinhardt, Jr.

Virginia Museum of Fine Arts, Richmond. *American Painting 1970.* Text by Peter Selz.

1971 Whitney Museum of American Art, New York. *The Structure of Color.* Texts by the artists and Marcia Tucker.

1972 Institute of Contemporary Art, University of Pennsylvania, Philadelphia. *Grids Grids Grids Grids Grids Grids Grids Grids.*

Museum Fridericianum, Kassel. *documenta 5: Internationale Ausstellung.*

1973 University of Maryland Art Gallery, College Park. *The Private Collection of Martha Jackson.* Texts by David Anderson, Adelyn Breeskin, Richard Klank, George Levitine and Elayne Varian.

1975 Albright-Knox Art Gallery, Buffalo. *The Martha Jackson Collection at the Albright-Knox Art Gallery.* Text by Linda L. Cathcart.

Museo de Arte Moderno, Mexico City. *Color.* Introduction by Kynaston McShine.

1976 The Solomon R. Guggenheim Museum, New York. *Acquisition Priorities: Aspects of Postwar Painting in America.* Text by Thomas M. Messer.

1977 Philadelphia College of Art. *Time.* Text by Janet Kardon.

San Francisco Museum of Modern Art. *Collectors, Collecting, Collection: American Abstract Art since 1945.* Introduction by Henry Hopkins.

Whitney Museum of American Art, New York. *1977 Biennial Exhibition: Contemporary American Art.* Texts by Barbara Haskell, Patterson Sims and Marcia Tucker.

Periodicals

1952 L(a)F(arge), H(enry). "Alfred J. Jensen." *Art News,* vol. 51, no. 1 (March 1952), p. 54.

Z(wart), M(artin). "Alfred Jensen." *Art Digest,* vol. 26, no. 11 (March 1952), p. 22.

1955 C. L. F. "Alfred Jensen." *Arts,* vol. 30, no. 2 (November 1955), p. 53.

S(chuyler), J(ames). "Alfred Jensen: Tanager." *Art News,* vol. 54, no. 8 (December 1955), p. 57.

1957 S(chuyler), J(ames). "Alfred Jensen: Schaefer." *Art News,* vol. 56, no. 7 (November 1957), p. 14.

S(eckler), D(orothy). "Alfred Jensen." *Arts,* vol. 32, no. 2 (November 1957), p. 60.

1959 D(ennison), G(eorge). "Alfred Jensen." *Arts,* vol. 34, no. 3 (December 1959), pp. 57-58.

Jensen, Alfred, "Statement." *It Is,* no. 4 (Autumn 1959), p. 15.

S(andler), I(rving) H. "Alfred Jensen: Jackson." *Art News,* vol. 58, no. 4 (Summer 1959), p. 17.

S(awin), M(artica). "Alfred Jensen." *Arts,* vol. 33, no. 9 (June 1959), pp. 62-63.

S(chuyler), J(ames). "Alfred Jensen: Jackson." *Art News,* vol. 58, no. 8 (December 1959), p. 17.

1960 Jensen, Alfred. "The Promise." *The Hasty Papers: A One-Shot Review* (1960), pp. 49-50.

1961 C(rehan), H(ubert). "Alfred Jensen: Jackson." *Art News,* vol. 59, no. 9 (January 1961), pp. 11-12.

Sandler, Irving H. "In the Art Galleries." *New York Post* (1 October 1961), p. 12.

S(awin), M(artica). "Alfred Jensen." *Arts,* vol. 35, no. 4 (January 1961), p. 61.

"Solomon R. Guggenheim Museum: American Abstract Expressionists and Imagists." *Das Kunstwerk,* vol. 15, no. 4 (November 1961), p. 59.

1963 J(udd), D(onald). "Al Jensen." *Arts Magazine,* vol. 37, no. 7 (April 1963), p. 53.

Kaprow, Allan. "The World View of Alfred Jensen." *Art News,* vol. 62, no. 7 (December 1963), pp. 28-31; 64-66.

S(andler), I(rving) H. "Reviews and Previews: Alfred Jensen." *Art News,* vol. 62, no. 1 (March 1963), p. 15.

S(taber), M(argit). "Schweizer Notizen: Alfred Jensen." *Art International,* vol. VII, no. 10 (Christmas 1963-New Year 1964), p. 51.

1964 Ashton, Dore. "Alfred Jensen: Graham Gallery." *Studio International,* vol. 167, no. 849 (January 1964), pp. 42-43.

D(anieli), F(idel) A. "Alfred Jensen: Rolf Nelson Gallery." *Artforum,* vol. II, no. 10 (April 1964), p. 45.

"Fifty-Six Painters and Sculptors." *Art in America,* vol. 52, no. 4 (August 1964), p. 40.

H(arrison), J(ane). "Alfred Jensen." *Arts Magazine,* vol. 38, no. 4 (January 1964), p. 35.

Margules, De Hirsh. "Reply to 'World View of Alfred Jensen'." *Art News,* vol. 62, no. 9 (January 1964), p. 6.

1965 H(oene), A(nne). "Alfred Jensen." *Arts Magazine,* vol. 39, nos. 8-9 (May-June 1965), pp. 57-58.

L(evine), N(eil) A. "Alfred Jensen." *Art News,* vol. 64, no. 3 (May 1965), p. 10.

1966 "Ausstellung in Zürich." *Werk,* vol. 53, no. 6 (June 1966), p. 142.

C(oplans), J(ohn). "Los Angeles: Object Lesson: Prints by Alfred Jensen." *Art News,* vol. 64, no. 9 (January 1966), p. 67.

F(actor), D(on). "Alfred Jensen: Rolf Nelson Gallery." *Artforum,* vol. IV, no. 5 (January 1966), p. 15.

1967 Bochner, Mel. "The Serial Attitude." *Artforum*, vol. VI, no. 4 (December 1967), pp. 28-33.

1968 Dienst, R. G. "Ausstellungen in New York." *Das Kunstwerk*, vol. 21, nos. 6-7 (April 1968), p. 24.

N(emser), C(indy). "Treasures from Inventory III." *Arts Magazine*, vol. 42, no. 3 (December 1967-January 1968), p. 52.

1970 B(ishop), J(ames). "Alfred Jensen: Cordier & Ekstrom." *Art News*, vol. 69, no. 3 (May 1970), p. 68.

D(omingo), W(illis). "Alfred Jensen at Cordier & Ekstrom." *Arts Magazine*, vol. 44, no. 6 (April 1970), p. 59.

Glueck, Grace. "Something for Every Appetite: New York Gallery Notes." *Art in America*, vol. 58, no. 2 (March-April 1970), p. 150.

Jensen, Alfred. "The Reciprocal Relation of Unity 20, 1969." *Art Now: New York*, vol. 2, no. 4 (1970), n.p.

Moore, Ethel, ed. "Letters from 31 Artists to the Albright-Knox Art Gallery." *Gallery Notes*, vols. XXXI and XXXII, no. 2 (Spring 1970), p. 17.

Vinklers, Bitite. "New York: Alfred Jensen." *Art International*, vol. XIV, no. 5 (May 1970), pp. 85-86.

1972 Matthais, Rosemary. "Alfred Jensen." *Arts Magazine*, vol. 48, no. 8 (Summer 1972), p. 60.

Schjeldahl, Peter. "Ever Intimidated by a Painting?" *New York Times* (28 May 1972), p. 17.

1973 J(ürgen-Fischer), K(laus). "Alfred Jensen." *Das Kunstwerk*, vol. XXVI, no. 4 (July 1973), p. 38.

Loring, John. "Checkers with the Right Man." *Arts Magazine*, vol. 47, no. 5 (March 1973), pp. 60-62.

Perreault, John. "Painting by Mystical Numbers." *The Village Voice* (8 November 1973), p. 19.

Winter, Peter. "Alfred Jensen." *Das Kunstwerk*, vol. XXVI, no. 2 (March 1973), pp. 79-80.

Zemel, Carol. "New York; Alfred Jensen." *Artscanada*, vol. XXX, nos. 5-6, issue nos. 184, 185, 186, 187 (December 1973-January 1974), p. 205.

1974 Stitelman, Paul. "Alfred Jensen." *Arts Magazine*, vol. 48, no. 4 (January 1974), p. 73.

1975 Daval, Jean-Luc. "Lettre de Suisse: Alfred Jensen." *Art International*, vol. 19, no. 7 (September 1975), p. 68.

Goldin, Amy. "Patterns, Grids and Painting." *Artforum*, vol. XIV, no. 1 (September 1975), pp. 50-54.

1976 Hess, Thomas B. "Alfred Jensen." *New York*, vol. 9, no. 5 (2 February 1976), p. 57.

Kramer, Hilton. "Alfred Jensen." *New York Times* (17 January 1976), p. 21.

Lorber, Richard. "Alfred Jensen." *Arts Magazine*, vol. 50, no. 7 (March 1976), p. 21.

1977 Ferretti, Fred. "Sending 'the best of America' abroad." *Art News*, vol. 76, no. 6 (Summer 1977), pp. 62-65.

Glueck, Grace. "Art People." *New York Times* (24 January 1977), p. 22.

Kuh, Katharine. "Art." *Saturday Review*, vol. 4, no. 22 (20 August 1977), pp. 52-54.

Manuscript/Interviews

1975 Musham, Leila Hadley. "Alfred Jensen: Metaphysical and Primitive" (1975, New York), unpublished.

Sandler, Irving H. and Torlen, Michael. Interview with Alfred Jensen (Glen Ridge, New Jersey, 15 May 1975), unpublished.

1977 Cathcart, Linda L. and Tucker, Marcia. Interview with Alfred Jensen (Glen Ridge, New Jersey, 30-31 March 1977), unpublished.

Crosman, Christopher and Miller, Nancy. Interview with Alfred Jensen (Glen Ridge, New Jersey, 6 April 1977), videotape.

Jensen, Regina Bogat. Interview with Alfred Jensen (Glen Ridge, New Jersey, August 1977), unpublished.

5000 copies of this catalogue, edited by Karen Spaulding, designed by
Paul McKenna, have been printed by Hoffman Printing, Buffalo, New
York on the occasion of the exhibition *Alfred Jensen: Paintings and
Diagrams From the Years 1957-1977.*

Credits
All photographs of paintings by Hans Namuth.
Portraits of Alfred Jensen,
p. 2 by Hans Namuth,
p. 27 by Paul Katz.
Installation view, p. 12 by Albert Winkler